A TREASURY
of
IRISH VERSE

EDITED AND INTRODUCED BY DAVID GIBBON

~

DESIGNED BY PHILIP CLUCAS

~

Featuring the photography of Michael Diggin,
The Irish Tourist Board, Tony Ruta,
Philip Clucas and Colour Library Books

Published by
CHARTWELL BOOKS, INC.
A Division of BOOK SALES, INC.
110 Enterprise Avenue
Secaucus, New Jersey 07094

CLB 2937
© 1992 CLB Publishing,
Godalming, Surrey, England
All rights reserved
Printed and bound in Singapore
ISBN 1-55521-888-1

A TREASURY
of
IRISH VERSE

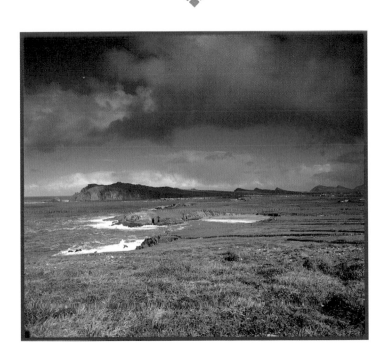

The Dingle Peninsula, Co. Kerry

**CHARTWELL
BOOKS, INC.**

CONTENTS

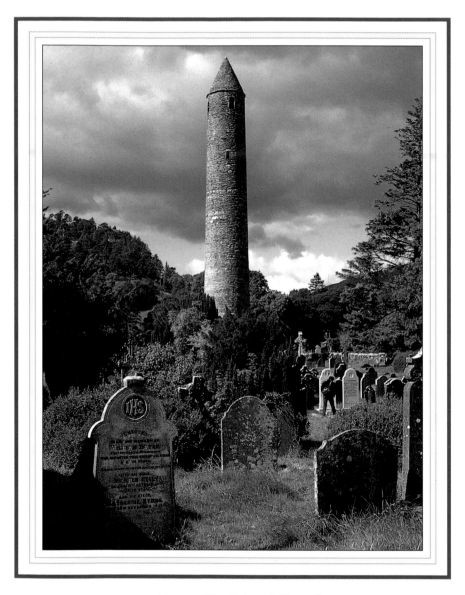

Above: Glendalough Round
Tower, Co. Wicklow

INTRODUCTION

*P*oets write of many things. They write of love and passion, hope and despair, of the beauty of the things and places they love, and of the land they call home. They open their hearts, and in turn open our eyes, for they are themselves open to emotions that most of us are either not aware of or are unable to express. Although this is true of all people, of none is it truer than of the Irish. The songs they sing, and the poetry they write, is part of an extraordinarily rich heritage that stretches back into the dim, distant past, to the legends and myths with which Ireland is so richly endowed.

Great literary figures whose works are known the world over illuminate Ireland's literary history. But there are other, lesser known poets and writers whose work enriches that history in equal measure, from anonymous monks toiling in their tiny cells and poets whose names are almost forgotten, to those writers of today whose work has yet to achieve recognition.

Although this is not a book of poems and songs solely *about* Ireland, every page is *of* Ireland. The unique character of the Irish, their joy and their sadness, their hopes and aspirations, their deep and abiding love of their homeland, shines through in every line.

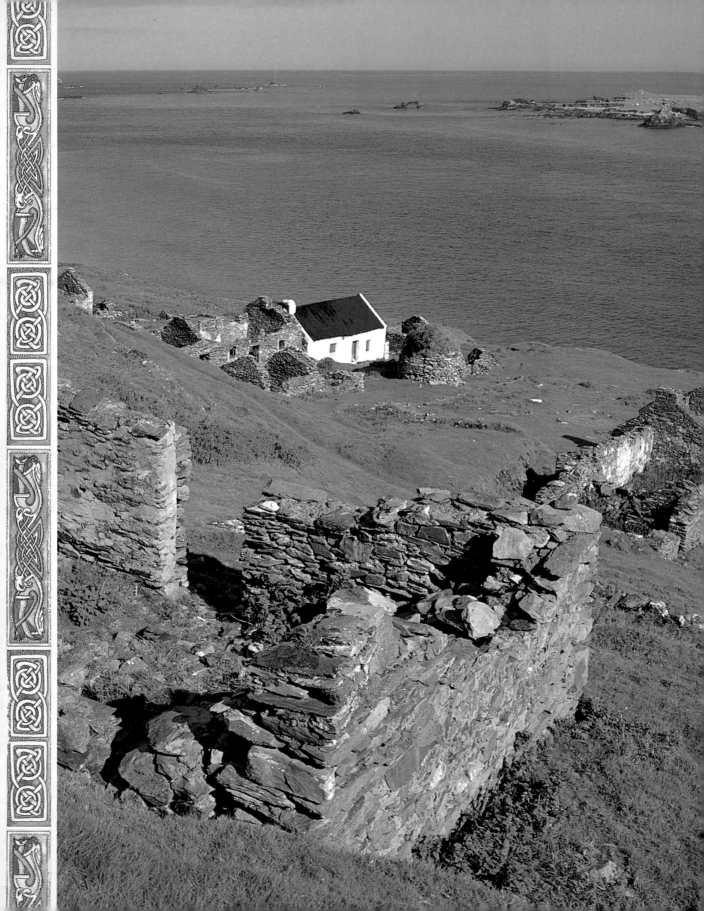

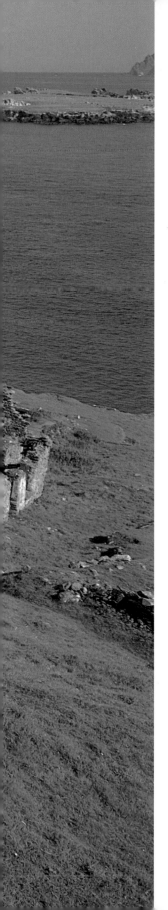

HOUSE ON A CLIFF

*I*ndoors the tang of a tiny oil lamp. Outdoors
The winking signal on the waste of sea.
Indoors the sound of the wind. Outdoors the wind.
Indoors the locked heart and the lost key.

Outdoors the chill, the void, the siren. Indoors
The strong man pained to find his red blood cools,
While the blind clock grows louder, faster. Outdoors
The silent moon, the garrulous tides she rules.

Indoors ancestral curse-cum-blessing. Outdoors
The empty bowl of heaven, the empty deep.
Indoors a purposeful man who talks at cross
Purposes, to himself, in a broken sleep.

LOUIS MACNEICE (1907-1963)

Left: Clifftop house on
the Blasket Islands

IN CARROWDORE CHURCHYARD
AT THE GRAVE OF LOUIS MACNEICE

Your ashes will not stir, even on this high ground,
However the wind tugs, the headstones shake.
This plot is consecrated, for your sake,
To what lies in the future tense. You lie
Past tension now, and spring is coming round
Igniting flowers on the peninsula.

Your ashes will not fly, however the rough winds burst
Through the wild brambles and the reticent trees.
All we may ask of you we have. The rest
Is not for publication, will not be heard.
Maguire, I believe, suggested a blackbird
And over your grave a phrase from Euripides.

Which suits you down to the ground, like this churchyard
With its play of shadow, its humane perspective.
Locked in the winter's fist, these hills are hard
As nails, yet soft and feminine in their turn
When fingers open and the hedges burn.
This, you implied, is how we ought to live –

The ironical, loving crush of roses against snow,
Each fragile, solving ambiguity. So
From the pneumonia of the ditch, from the ague
Of the blind poet and the bombed-out town you bring
The all-clear to the empty holes of spring;
Rinsing the choked mud, keeping the colours new.

DEREK MAHON (1941-)

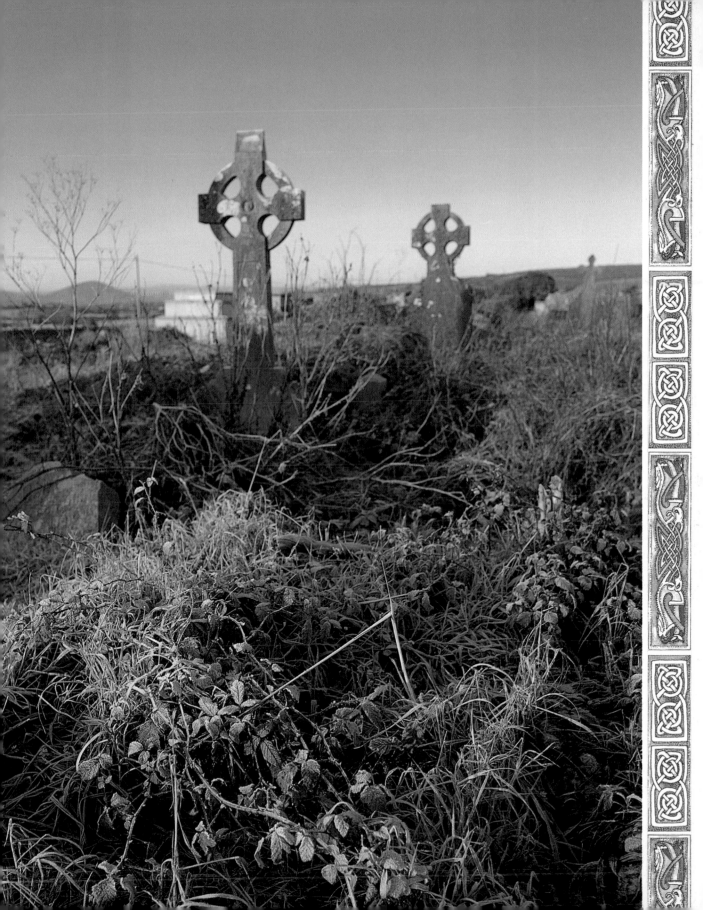

JUNE

*B*room out the floor now, lay the fender by,
And plant this bee-sucked bough of woodbine there,
 And let the window down. The butterfly
Floats in upon the sunbeam, and the fair
 Tanned face of June, the nomad gipsy, laughs
Above her widespread wares, the while she tells
 The farmers' fortunes in the fields, and quaffs
The water from the spider-peopled wells.

 The hedges all are drowned in green grass seas,
And bobbing poppies flare like Elmo's light,
 While siren-like the pollen stainéd bees
Drone in the clover depths. And up the height
 The cuckoo's voice is hoarse and broke with joy.
And on the lowland crops the crows make raid,
 Nor fear the clappers of the farmer's boy,
Who sleeps, like drunken Noah, in the shade.

 And loop this red rose in that hazel ring
That snares your little ear, for June is short
 And we must joy in it and dance and sing,
 And from her bounty draw her rosy worth.
 Ay! soon the swallows will be flying south,
 The wind wheel north to gather in the snow,
 Even the roses spilt on youth's red mouth
 Will soon blow down the road all roses go.

FRANCIS LEDWIDGE (1891-1917)

THE FORGE

All I know is a door into the dark.
Outside, old axles and iron hoops rusting;
Inside, the hammered anvil's short-pitched ring,
The unpredictable fantail of sparks
Or hiss when a new shoe toughens in water.
The anvil must be somewhere in the centre,
Horned as a unicorn, at one end square,
Set there immovable: an altar
Where he expends himself in shape and music.
Sometimes, leather-aproned, hairs in his nose,
He leans out on the jamb, recalls a clatter
Of hoofs where traffic is flashing in rows;
Then grunts and goes in, with a slam and flick
To beat real iron out, to work the bellows.

SEAMUS HEANEY (1939-)

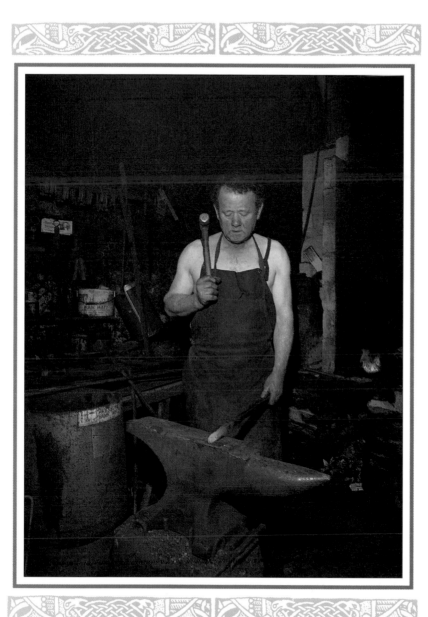

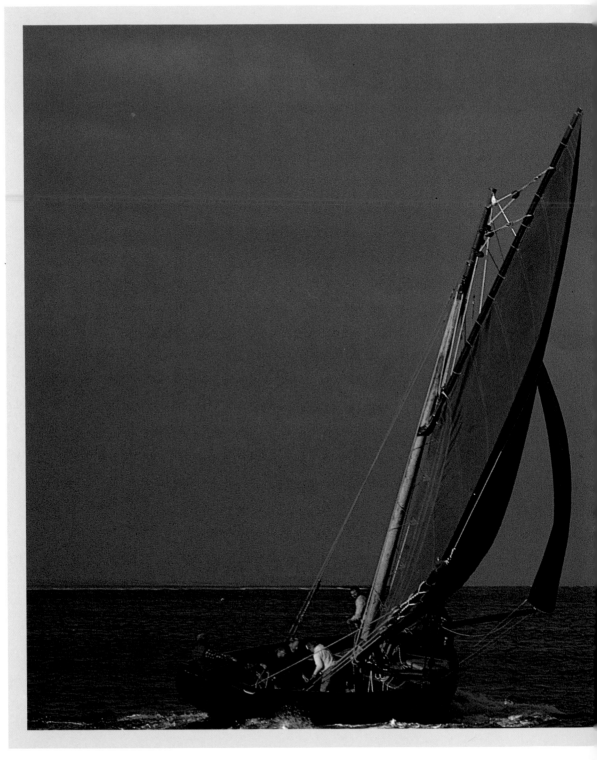

DARK ROSALEEN

(From the Irish of Costello)

O my Dark Rosaleen,
 Do not sigh, do not weep!
The priests are on the ocean green,
 They march along the Deep.
There's wine ... from the royal Pope
 Upon the ocean green;
And Spanish ale shall give you hope,
 My Dark Rosaleen!
 My own Rosaleen!
Shall glad your heart, shall give you hope,
Shall give you health, and help, and hope,
 My Dark Rosaleen.

Over hills and through dales,
 Have I roamed for your sake;
All yesterday I sailed with sails
 On river and on lake.
The Erne ... at its highest flood
 I dashed across unseen,
For there was lightning in my blood,
 My Dark Rosaleen!
 My own Rosaleen!
Oh! there was lightning in my blood,
Red lightning lightened through my blood,
 My Dark Rosaleen!

All day long in unrest
 To and fro do I move,
The very soul within my breast
 Is wasted for you, love!

continued...

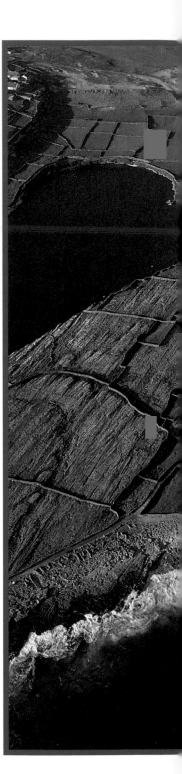

The heart ... in my bosom faints
 To think of you my Queen,
My life of life, my saint of saints,
 My Dark Rosaleen!
 My own Rosaleen!
To hear your sweet and sad complaints,
My life, my love, my saint of saints,
 My Dark Rosaleen!

Woe and pain, pain and woe,
 Are my lot night and noon,
To see your bright face clouded so,
 Like to the mournful moon.
But yet ... I will rear your throne
 Again in golden sheen;
'Tis you shall reign, shall reign alone,
 My Dark Rosaleen!
 My own Rosaleen!
'Tis you shall have the golden throne,
'Tis you shall reign, and reign alone
 My Dark Rosaleen!

Over dews, over sands
 Will I fly for your weal;
Your holy delicate white hands
 Shall girdle me with steel.
At home ... in your emerald bowers,
 From morning's dawn till e'en,
You'll pray for me, my flower of flowers,
 My Dark Rosaleen!
 My fond Rosaleen!
You'll think of me through daylight's hours,
My virgin flower, my flower of flowers,
 My Dark Rosaleen! continued...

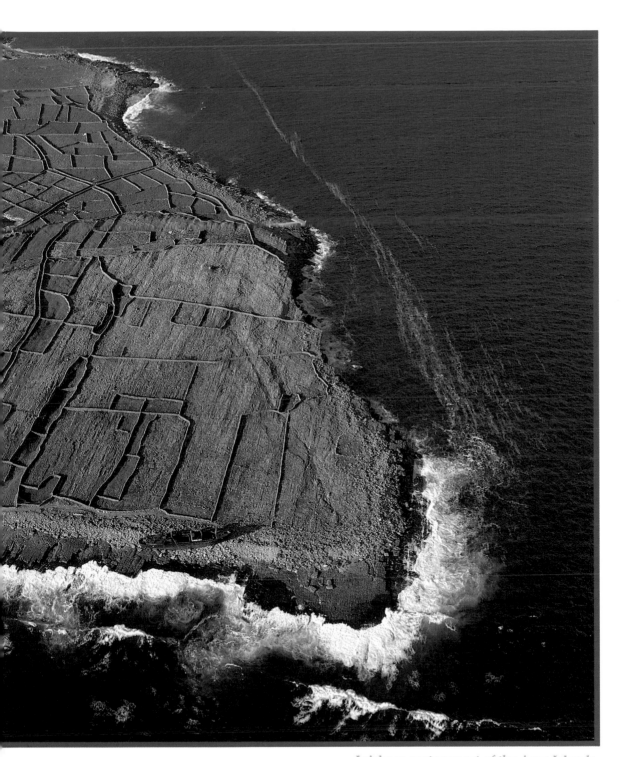

Inisheer, easternmost of the Aran Islands

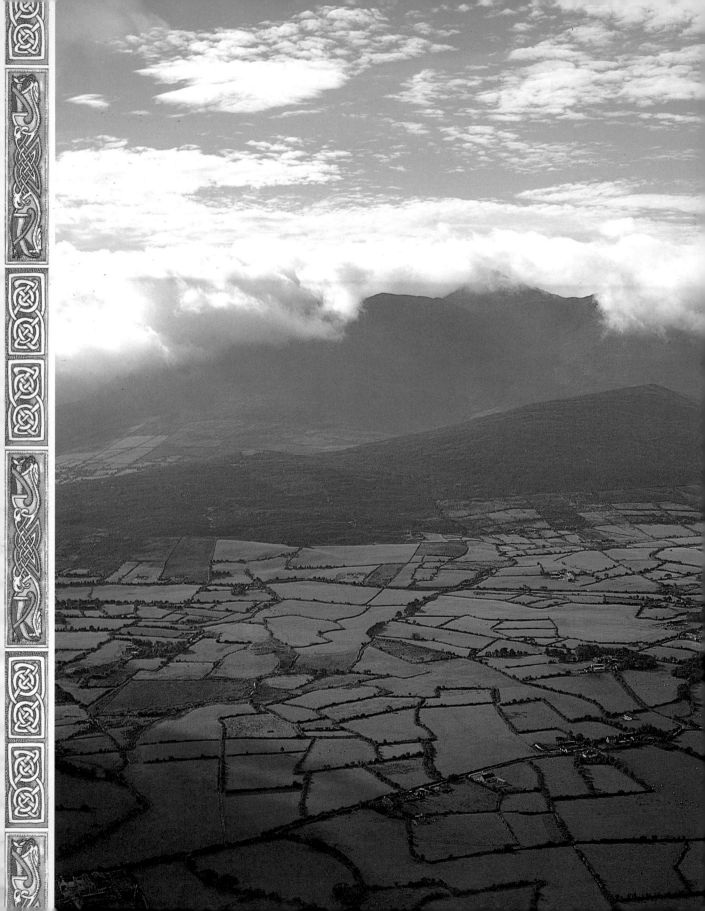

I could scale the blue air,
　　　I could plough the high hills,
Oh, I could kneel all night in prayer,
　　　To heal your many ills!
And one ... beamy smile from you
　　　Would float like light between
My toils and me, my own, my true,
　　　My Dark Rosaleen!
　　　My fond Rosaleen!
Would give me life and soul anew,
A second life, a soul anew,
　　　My Dark Rosaleen!

O! the Erne shall run red
　　　With redundance of blood,
The earth shall rock beneath our tread,
　　　And flames wrap hill and wood,
And gun-peal, and slogan cry,
　　　Wake many a glen serene,
Ere you shall fade, ere you shall die,
　　　My Dark Rosaleen!
　　　My own Rosaleen!
The Judgement Hour must first be nigh,
Ere you can fade, ere you can die,
　　　My Dark Rosaleen!

JAMES CLARENCE MANGAN (1803-1849)

Left: Macgillycuddy's
Reeks, Co. Kerry

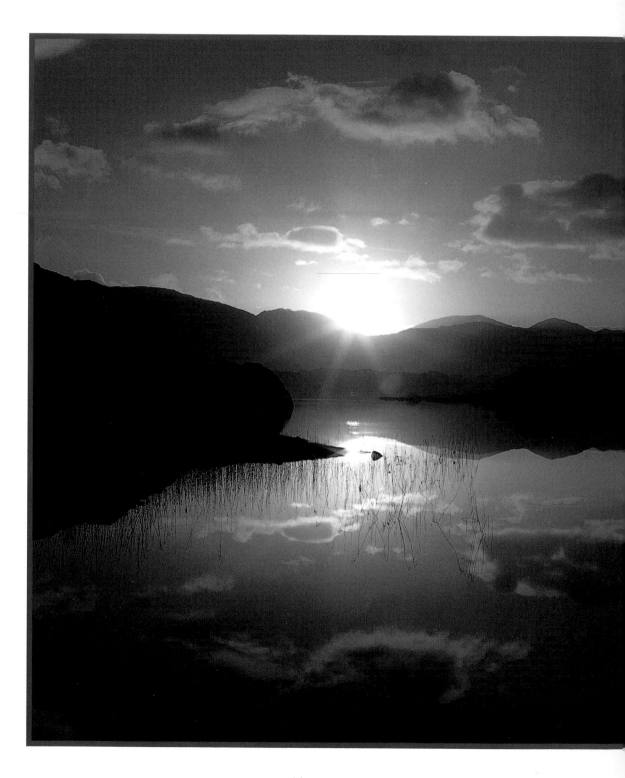

HE WISHES FOR THE CLOTHS OF HEAVEN

*H*ad I the heavens' embroidered cloths,
Enwrought with golden and silver light,
 The blue and the dim and the dark cloths
Of night and light and the half-light,
 I would spread the cloths under your feet:
But I, being poor, have only my dreams;
 I have spread my dreams under your feet;
Tread softly because you tread on my dreams.

W.B. YEATS (1865-1939)

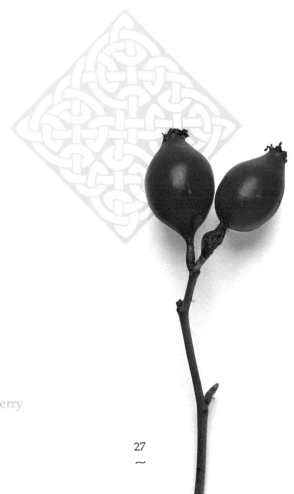

The Ring of Kerry

27
~

GOING HOME TO MAYO, WINTER, 1949

Leaving behind us the alien, foreign city of Dublin
My father drove through the night in an old Ford Anglia,
His five-year-old son in the seat beside him,
The rexine seat of red leatherette,
And a yellow moon peeped in through the windscreen.
'Daddy, Daddy,' I cried, 'Pass out the moon,'
But no matter how hard he drove he could not pass out the moon.
Each town we passed through was another milestone
And their names were magic passwords into eternity:
Kilcock, Kinnegad, Strokestown, Elphin,
Tarmonbarry, Tulsk, Ballaghderreen, Ballavarry;
Now we were in Mayo and the next stop was Turlough,
The village of Turlough in the heartland of Mayo,
And my father's mother's house, all oil-lamps and women,
And my bedroom over the public bar below,
And in the morning cattle-cries and cock-crows:
Life's seemingly seamless garment gorgeously rent
By their screeches and bellowings. And in the evenings
I walked with my father in the high grass down by the river
Talking with him – an unheard-of thing in the city.

But home was not home and the moon could be no more outflanked
Than the daylight nightmare of Dublin city:
Back down along the canal we chugged into the city
And each lock-gate tolled our mutual doom;
And railing and palings and asphalt and traffic-lights,
And blocks after blocks of so-called 'new' tenements –
Thousands of crosses of loneliness planted
In the narrowing grave of the life of the father;
In the wide, wide cemetery of the boy's childhood.

PAUL DURCAN (1944-)

28

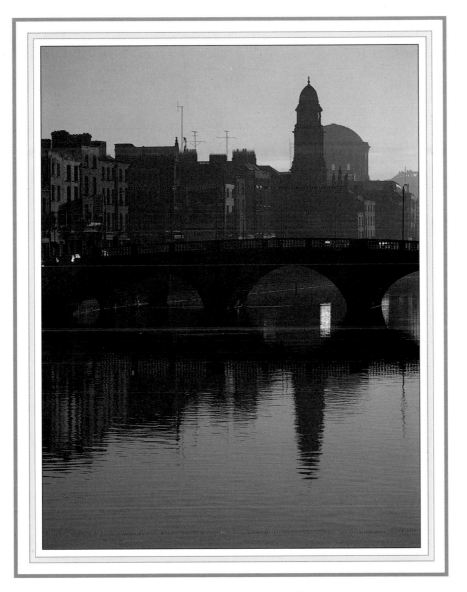

The River Liffey, Dublin City

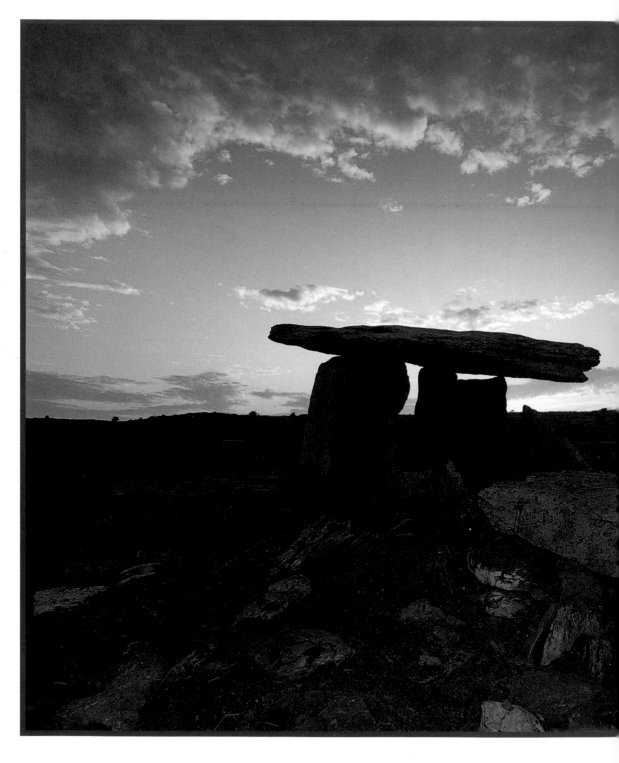

IRELAND

I called you by sweet names by wood and linn,
You answered not because my voice was new,
And you were listening for the hounds of Finn
 And the long hosts of Lugh.

And so, I came unto a windy height
And cried my sorrow, but you heard no wind,
For you were listening to small ships in flight,
 And the wail on hills behind.

And then I left you, wandering the war
Armed with will, from distant goal to goal,
To find you at the last free as of yore,
 Or die to save your soul.

And then you called to us from far and near
To bring your crown from out the deeps of time,
It is my grief your voice I couldn't hear
 In such a distant clime.

FRANCIS LEDWIDGE (1891-1917)

Left: The Poulnabrone dolmen, Co. Clare

THE LAKE ISLE OF INNISFREE

I will arise and go now, and go to Innisfree,
 And a small cabin build there, of clay and wattles made:
Nine bean-rows will I have there, a hive for the honey-bee,
 And live alone in the bee-loud glade.

And I shall have some peace there, for peace comes dropping slow,
Dropping from the veils of the morning to where the cricket sings;
There midnight's all a glimmer, and noon a purple glow,
 And evening full of the linnet's wings.

I will arise and go now, for always night and day
I hear lake water lapping with low sounds by the shore;
While I stand on the roadway, or on the pavements grey,
 I hear it in the deep heart's core.

W.B. YEATS (1865-1939)

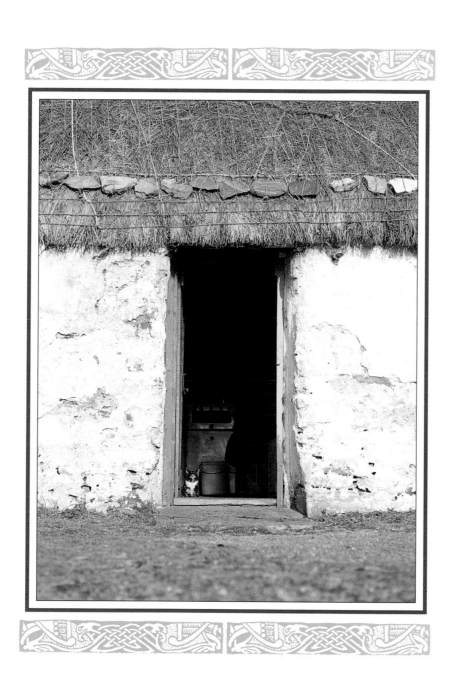

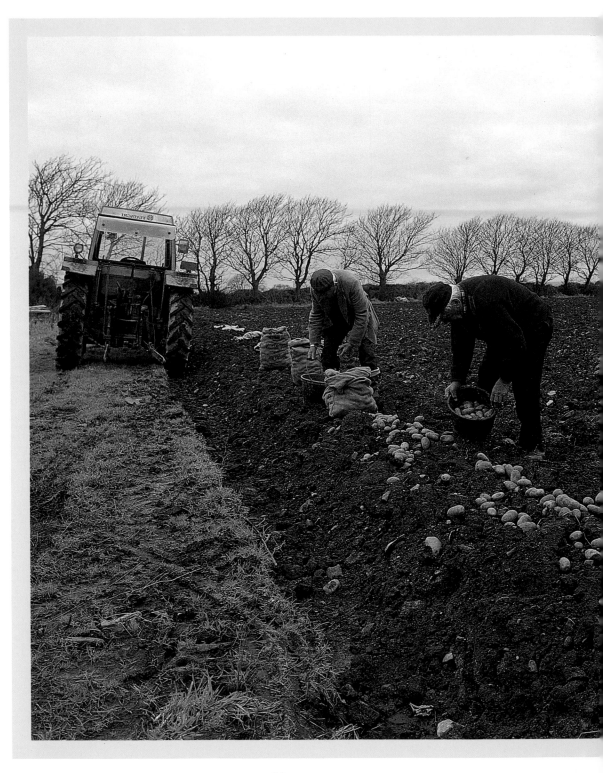

AT A POTATO DIGGING

A mechanical digger wrecks the drill,
Spins up a dark shower of roots and mould.
Labourers swarm in behind, stoop to fill
Wicker creels. Fingers go dead in the cold.

Like crows attacking crow-black fields, they stretch
A higgledy line from hedge to headland;
Some pairs keep breaking ragged ranks to fetch
A full creel to the pit and straighten, stand

Tall for a moment but soon stumble back
To fish a new load from the crumbled surf.
Heads bow, trunks bend, hands fumble towards the black
Mother. Processional stooping through the turf

Recurs mindlessly as autumn. Centuries
Of fear and homage to the famine god
Toughen the muscles behind their humbled knees,
Make a seasonal altar of the sod.

SEAMUS HEANEY (1939-)

OPENING LINES FROM
THE MIDNIGHT COURT

*B*y the brink of the river I'd often walk,
 on a meadow fresh, in the heavy dew,
along the woods, in the mountain's heart,
 happy and brisk in the brightening dawn.

My heart would lighten to see Loch Gréine,
 the land, the view, the sky horizon,
the sweet and delightful set of the mountains
 looming their heads up over each other.

It would brighten a heart worn out with time,
 or spent, or faint, or filled with pain
– or the withered, the sour, without wealth or means –
 to gaze for a while across the woods
at the shoals of ducks on the cloudless bay
 and a swan between them, sailing with them,
at fishes jumping on high for joy,
 the flash of a stripe-bellied glittering perch,
the hue of the lake, the blue of the waves
 heavy and strong as they rumble in.

There were birds in the trees, cintent and gay,
 a leaping doe in the wood nearby,
sounding horns, a crowd in view,
 and Reynard ahead of the galloping hounds.

BRIAN MERRIMAN (1749-1805)

Right: Lough Acumeen, Co. Kerry

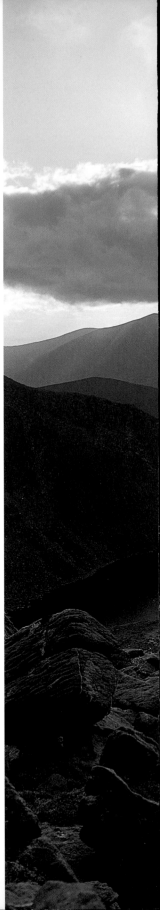

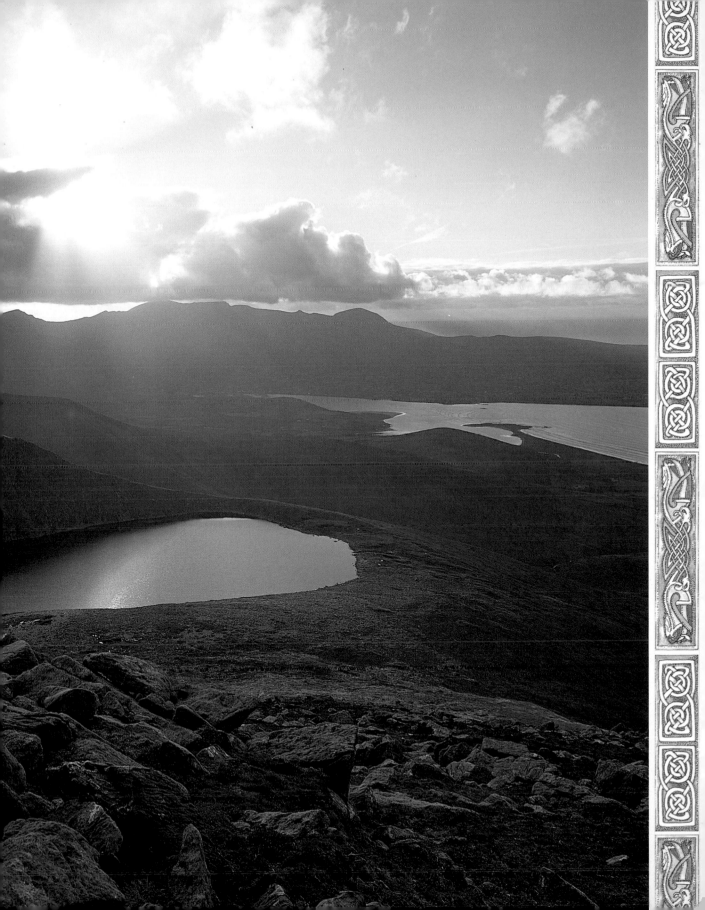

OCTOBER

O leafy yellowness you create for me
A world that was and now is poised above time,
 I do not need to puzzle out Eternity
As I walk this arboreal street on the edge of a town.
The breeze too, even the temperature
And pattern of movement is precisely the same
 As broke my heart for youth passing. Now I am sure
 Of something. Something will be mine wherever I am.
I want to throw myself on the public street without caring
For anything but the prayering that the earth offers.
 It is October all over my life and the light is staring
 As it caught me once in a plantation by the fox coverts.
A man is ploughing ground for winter wheat
And my nineteen years weigh heavily on my feet.

PATRICK KAVANAGH (1904-1967)

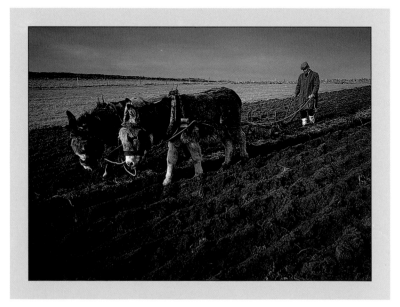

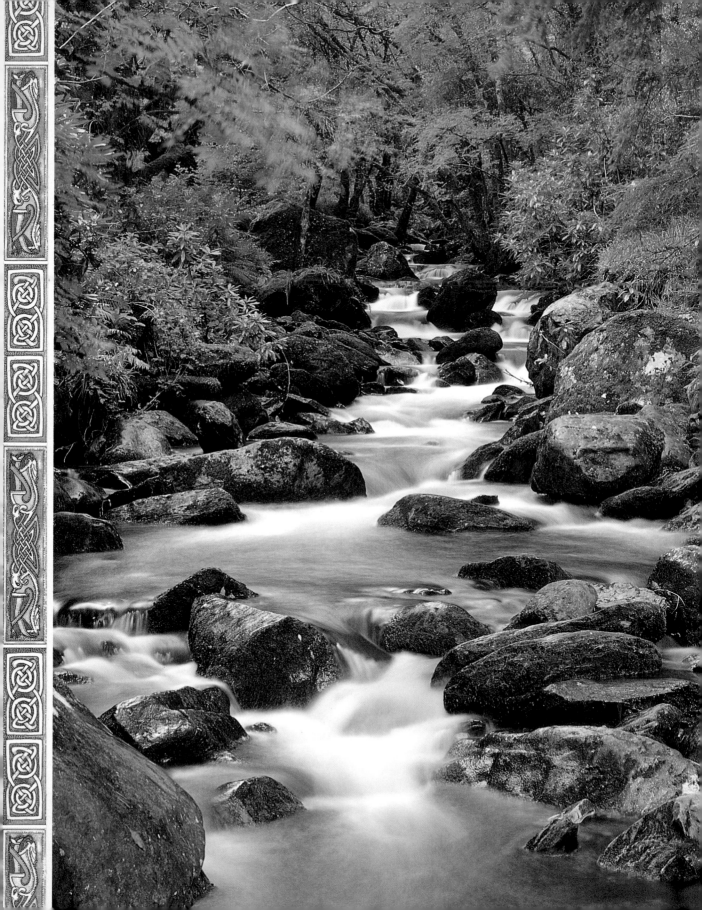

HER VOICE COULD
NOT BE SOFTER

*S*uddenly in the dark wood
She turned from my arms and cried
As if her soul were lost,
And O too late I knew,
Although the blame was mine,
Her voice could not be softer
When she told it in confession.

AUSTIN CLARKE (1896-1974)

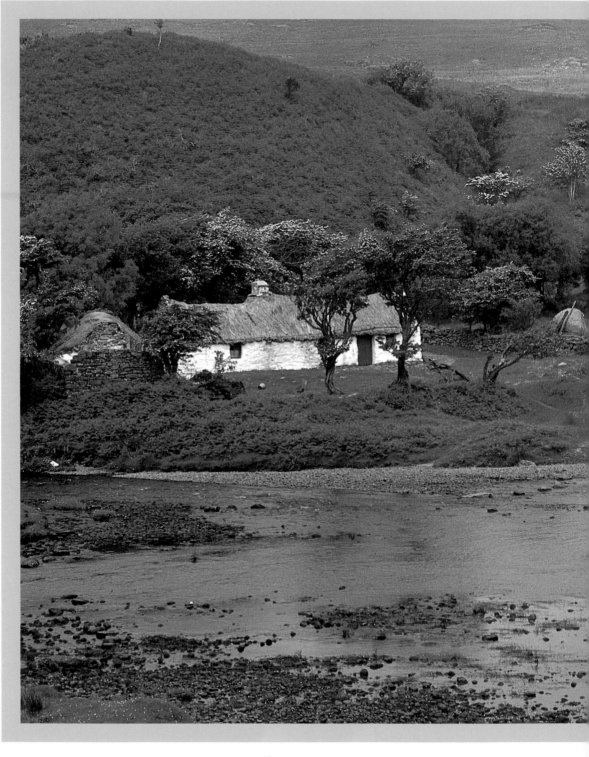

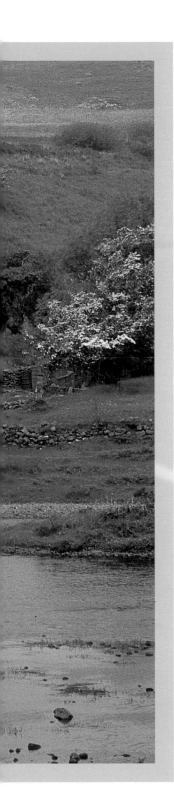

AN OLD WOMAN OF THE ROADS

O, to have a little house!
 To own the hearth and stool and all!
 The heaped up sods against the fire,
 The pile of turf against the wall!

 To have a clock with weights and chains
 And pendulum swinging up and down!
 A dresser filled with shining delph,
 Speckled and white and blue and brown!

I could be busy all the day
 Clearing and sweeping hearth and floor,
 And fixing on their shelf again
 My white and blue and speckled store!

 I could be quiet there at night
 Beside the fire and by myself,
 Sure of a bed and loth to leave
 The ticking clock and the shining delph!

Och! but I'm weary of mist and dark,
 And roads where there's never a house nor bush,
 And tired I am of bog and road,
 And the crying wind and the lonesome hush!

 And I am praying to God on high,
 And I am praying Him night and day,
 For a little house – a house of my own –
 Out of the wind's and the rain's way.

PADRAIC COLUM (1881-1972)

THE SUNLIGHT ON
THE GARDEN

The sunlight on the garden
 Hardens and grows cold,
 We cannot cage the minute
 Within its nets of gold,
 When all is told
 We cannot beg for pardon.

 Our freedom as free lances
 Advances towards its end;
 The earth compels, upon it
 Sonnets and birds descend;
 And soon, my friend,
 We shall have no time for dances.

The sky was good for flying
Defying the church bells
 And every evil iron
 Siren and what it tells:
The earth compels,
We are dying, Egypt, dying

 And not expecting pardon,
 Hardened in heart anew,
But glad to have sat under
Thunder and rain with you,
 And grateful too
 For sunlight on the garden.

LOUIS MACNEICE (1907-1963)

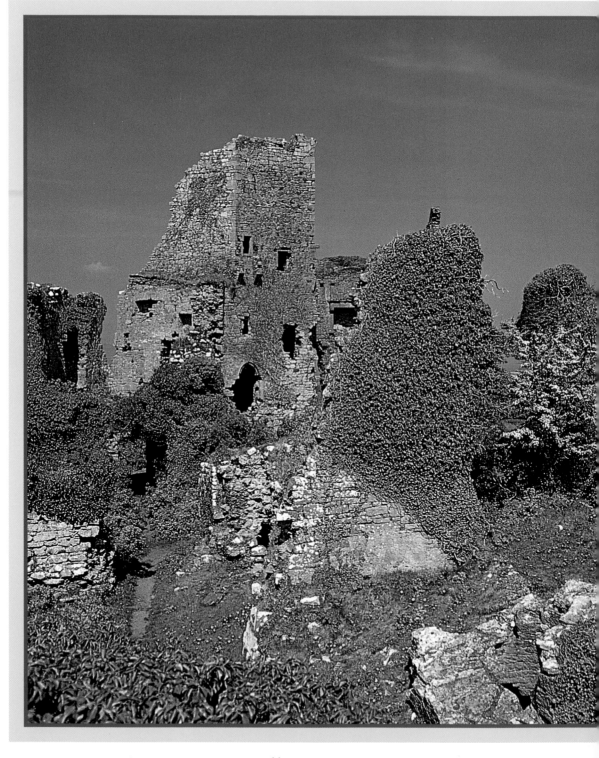

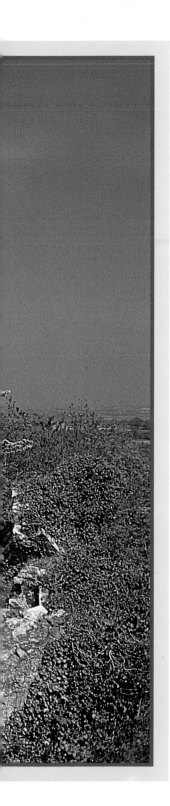

THE LIMERICK TRAIN

*H*urtling between hedges now, I see
Green desolation stretch on either hand
While sunlight blesses all magnanimously.

 The gods and heroes are gone for good and
 Men evacuate each Munster valley
 And midland plain, gravelly Connaught land

And Leinster town. Who, I wonder, fully
Understands the imminent predicament,
Sprung from rooted suffering and folly?

 Broken castles tower, lost order's monument,
 Splendour crumbling in sun and rain,
 Witnesses to all we've squandered and spent,

But no Phoenix rises from that ruin
Although the wild furze in yellow pride
Explodes in bloom above each weed and stone,

 Promise ablaze on every mountainside
 After the centuries' game of pitch-and-toss
 Separates what must live from what has died.

A church whips past, proclaiming heavy loss
Amounting to some forty thousand pounds;
A marble Christ unpaid for on His Cross

 Accepts the Limerick train's irreverent sound,
 Relinquishes great power to little men –
 A river flowing still, but underground.

Wheels clip the quiet counties. Now and then
I see a field where like an effigy
In rushy earth, there stands a man alone

Carrigogunnel Castle, Co. Limerick continued…

Lifting his hand in salutation. He
Disappears almost as soon as he is seen,
Drowned in distant anonymity.

We have travelled far, the journey has been
Costly, tormented odyssey through night;
And now, noting the unmistakable green,

The pools and trees that spring into the sight,
The sheep that scatter madly, wheel and run,
Quickly transformed to terrified leaping white,

I think of what the land has undergone
And find the luminous events of history
Intolerable as staring at the sun.

Only twenty miles to go and I'll be
Home. Seeing two crows low over the land,
I recognize the land's uncertainty,

The unsensational surrender and
Genuflexion to the busy stranger
Whose power in pocket brings him power in hand.

Realizing now how dead is anger
Such as sustained us at the very start
With possibility in time of danger,

I know why we have turned away, apart
(I'm moving still but so much time has sped)
From the dark realities of the heart.

From my window now, I try to look ahead
And know, remembering what's been done and said
That we must always cherish, and reject, the dead.

BRENDAN KENNELLY (1936-)

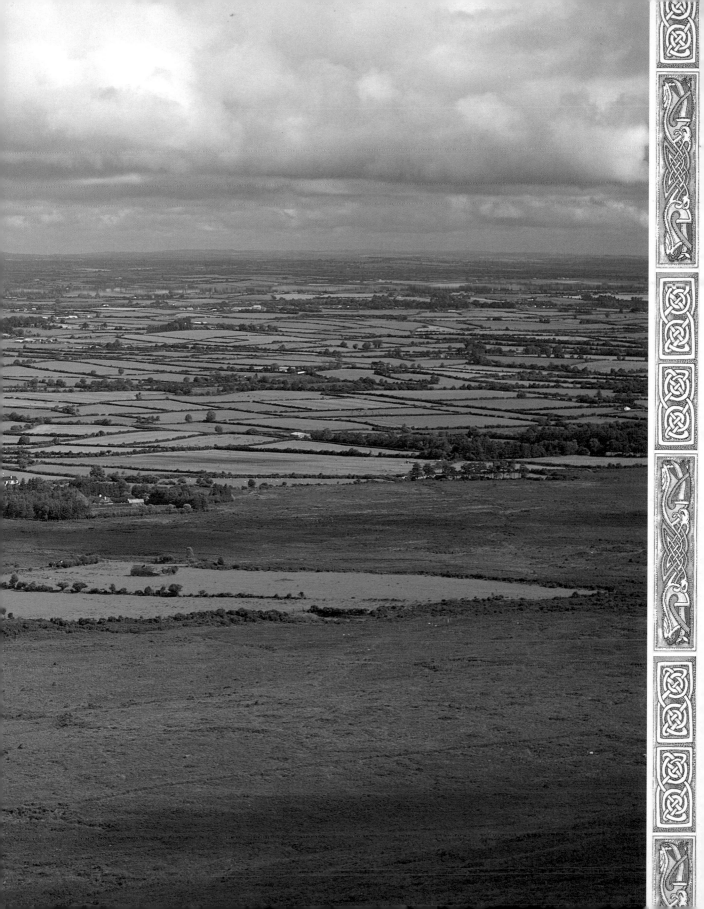

'THE APPLES RIPEN UNDER YELLOWING LEAVES'

The apples ripen under yellowing leaves,
And in the farm yards by the little bay
The shadows come and go amid the sheaves,
And on the long dry inland winding way:
Where, in the thinning boughs each air bereaves
Faint sunlights golden, and the spider weaves.
Grey are the low-laid sleepy hills, and grey
The autumn solitude of the sea day,
Where from the deep 'mid-channel, less and less
You hear along the pale east afternoon
A sound, uncertain as the silence, swoon –
The tide's sad voice ebbing toward loneliness:
And past the sands and seas' blue level line,
Ceaseless, the faint far murmur of the brine.

THOMAS CAULFIELD IRWIN (1823-1892)

Right: Connemara, Co. Galway

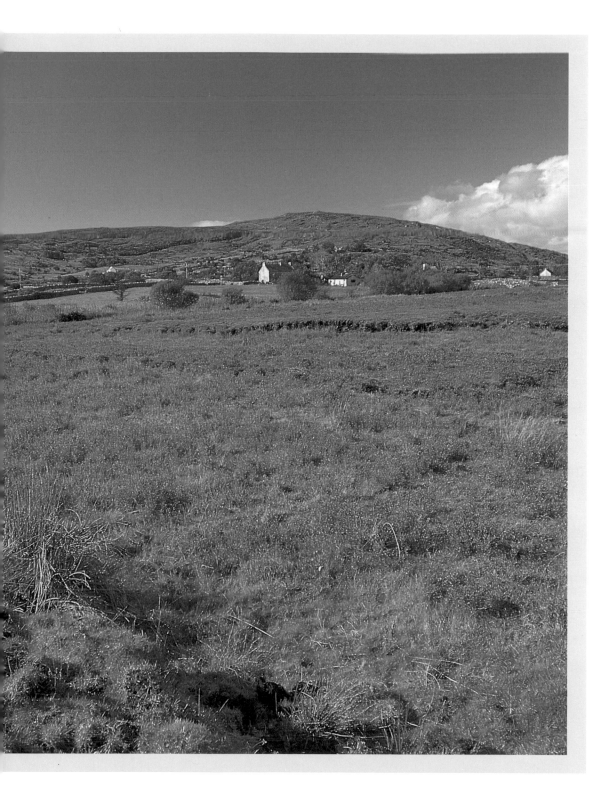

MARTHA BLAKE

*B*efore the day is everywhere
 And the timid warmth of sleep
Is delicate on limb, she dares
 The silence of the street
Until the double bells are thrown back
 For Mass and echoes bound
In the chapel yard, O then her soul
 Makes bold in the arms of sound.

But in the shadow of the nave
 Her well-taught knees are humble,
She does not see through any saint
 That stands in the sun
With veins of lead, with painful crown:
 She waits that dreaded coming,
When all the congregation bows
 And none may look up.

The word is said, the Word sent down,
 The miracle is done
Beneath those hands that have been rounded
 Over the embodied cup,
And with a few, she leaves her place
 Kept by an east-filled window
And kneels at the communion rail
 Starching beneath her chin.

She trembles for the Son of Man,
 While the priest is murmuring
What she can scarcely tell, her heart
 Is making such a stir;
But when he picks a particle
 And she puts out her tongue,
That joy is the glittering of candles
 And benediction sung.

Her soul is lying in the Presence
 Until her senses, one
By one, desiring to attend her,
 Come as for feast and run
So fast to share the sacrament,
 Her mouth must mother them:
'Sweet tooth grow wise, lip, gum be gentle,
 I touch a purple hem.'

Afflicted by that love she turns
 To multiply her praise,
Goes over all the foolish words
 And finds they are the same;
But now she feels within her breast
 Such calm that she is silent,
For soul can never bè immodest
 Where body may not listen.

continued...

On a holy day of obligation
 I saw her first in prayer,
But mortal eye had been too late
 For all that thought could dare.
The flame in heart is never grieved
 That pride and intellect
Were cast below, when God revealed
 A heaven for this earth.

So to begin the common day
 She needs a miracle,
Knowing the safety of angels
 That see her home again,
Yet ignorant of all the rest,
 The hidden grace that people
Hurrying to business
 Look after in the street.

AUSTIN CLARKE (1896-1974)

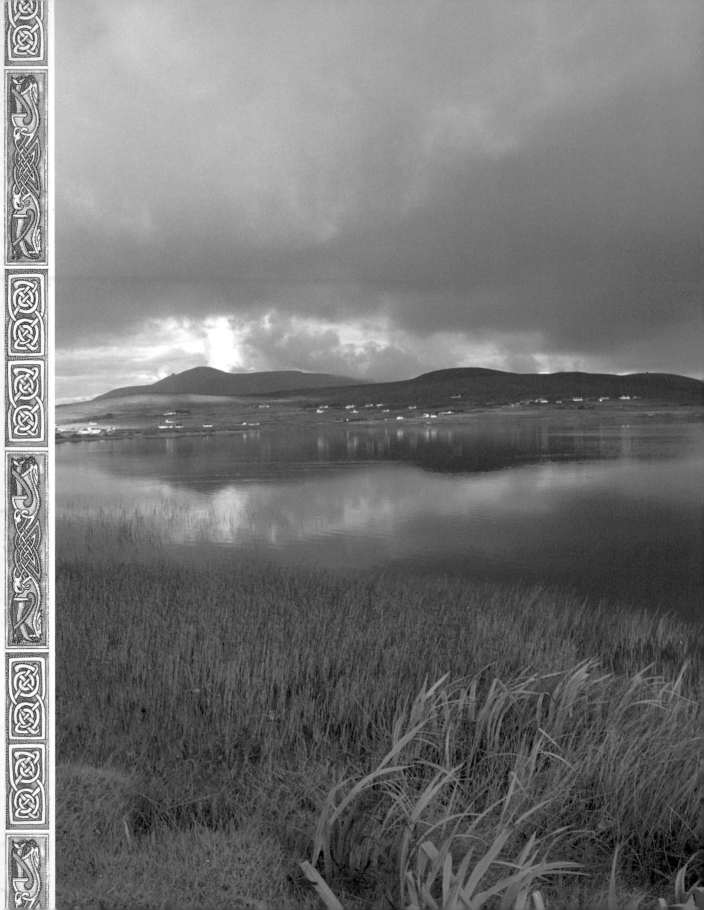

ACHILL

im chaonai uaigneach nach mór go bhfeicim an lá

I lie and imagine a first light gleam in the bay
 After one more night of erosion and nearer the grave,
Then stand and gaze from a window at break of day
 As a shearwater skims the ridge of an incoming wave;
And I think of my son a dolphin in the Aegean,
 A sprite among sails knife-bright in a seasonal wind,
And wish he were here where currachs walk on the ocean
 To ease with his talk the solitude locked in my mind.

I sit on a stone after lunch and consider the glow
 Of the sun through mist, a pearl bulb containèdly fierce;
A rain-shower darkens the schist for a minute or so
 Then it drifts away and the sloe-black patches disperse.
Croagh Patrick towers like Naxos over the water
 And I think of my daughter at work on her difficult art
And wish she were with me now between thrush and plover,
 Wild thyme and sea-thrift, to lift the weight from my heart.

The young sit smoking and laughing on the bridge at evening
 Like birds on a telephone pole or notes on a score.
A tin whistle squeals in the parlour, once more it is raining,
 Turfsmoke inclines and a wind whines under the door;
And I lie and imagine the lights going on in the harbour
 Of white-housed Náousa, your clear definition at night,
And wish you were here to upstage my disconsolate labour
 As I glance through a few thin pages and switch off the light.

DEREK MAHON (1941-)

Left: Achill Island, Co. Mayo

THE LAPFUL OF NUTS

Whene'er I see soft hazel eyes
 And nut-brown curls,
I think of those bright days I spent
 Among the Limerick girls;
When up through Cratla woods I went,
 Nutting with thee;
And we pluck'd the glossy clustering fruit
 From many a bending tree.

 Beneath the hazel boughs we sat,
 Thou, love, and I,
 And the gather'd nuts lay in thy lap,
 Beneath thy downcast eye:
 But little we thought of the store we'd won,
 I, love, or thou;
 For our hearts were full, and we dare not own
 The love that's spoken now.

Oh there's wars for willing hearts in Spain,
 And high Germanie!
And I'll come back, ere long again,
 With knightly fame and fee:
And I'll come back, if I ever come back,
 Faithful to thee,
That sat with thy white lap full of nuts
 Beneath the hazel tree.

SAMUEL FERGUSON (1810-1886)

THE ROCK OF CASHEL

*R*oyal and Saintly Cashel! I would gaze
 Upon the wreck of thy departed powers,
 Not in the dewy light of matin hours,
Nor the meridian pomp of summer's blaze,
But at the close of dim autumnal days,
 When the sun's parting glance, through slanting showers
 Sheds o'er thy rock-throned battlements and towers
Such awful gleams as brighten o'er Decay's
Prophetic cheek. At such a time, methinks,
 There breathes from thy lone courts and voiceless aisles
A melancholy moral, such as sinks
 On the lone traveller's heart, amid the piles
Of vast Persepolis on her mountain stand,
Or Thebes half buried in the desert sand.

SIR AUBREY DE VERE (1788-1846)

Right: The Rock of Cashel

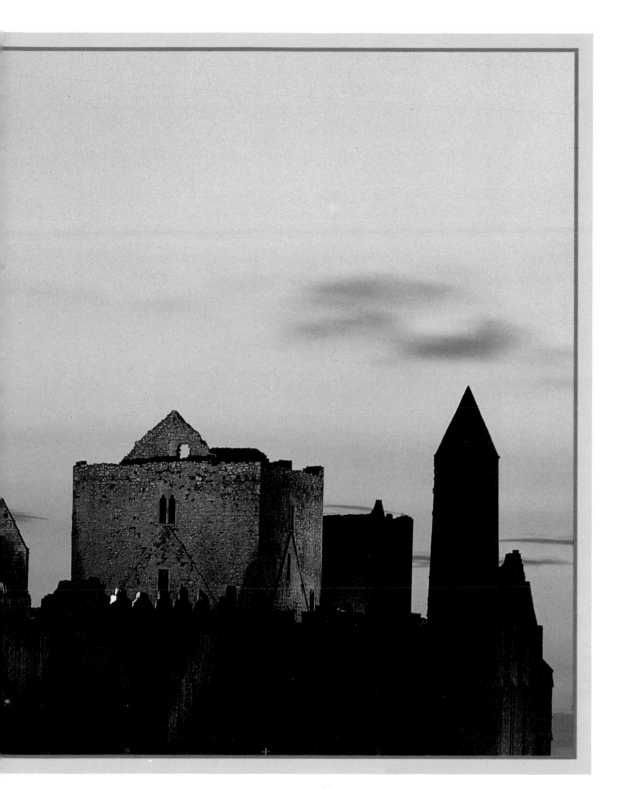

THE AVENUE

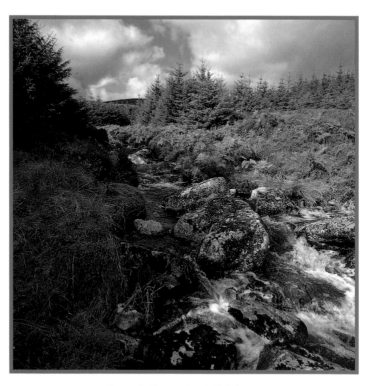

*N*ow that we've come to the end
I've been trying to piece it together,
Not that distance makes anything clearer.
It began in the half-light
While we walked through the dawn chorus
After a party that lasted all night,
With the blackbird, the wood-pigeon,
The song-thrush taking a bludgeon
To a snail, our taking each other's hand
As if the whole world lay before us.

PAUL MULDOON (1951-)

Lough Dan, Co. Wicklow

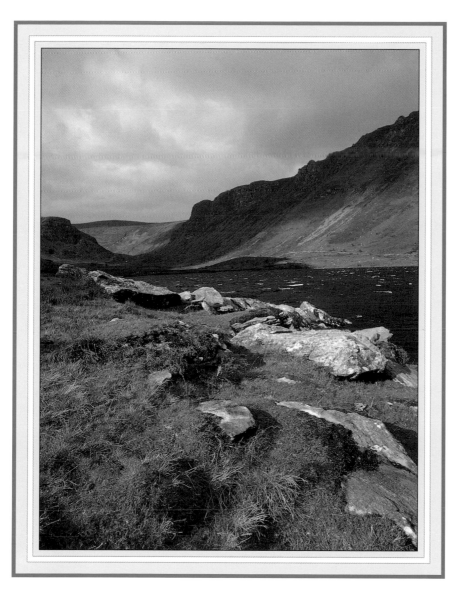

The Conner Pass, Co. Kerry

AFTER THE IRISH OF
EGAN O'RAHILLY

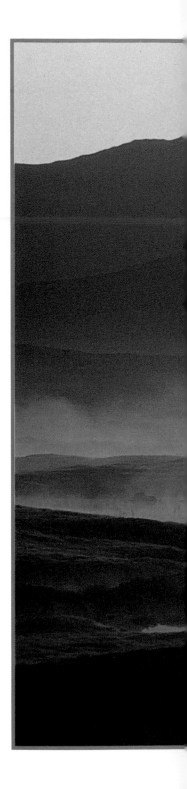

*W*ithout flocks or cattle or the curved horns
Of cattle, in a drenching night without sleep,
My five wits on the famous uproar
Of the wave toss like ships,
And I cry for boyhood, long before
Winkle and dogfish had defiled my lips.

O if he lived, the prince who sheltered me,
And his company who gave me entry
On the river of the Laune,
Whose royalty stood sentry
Over intricate harbours, I and my own
Would not be desolate in Dermot's country.

Fierce McCarthy Mor whose friends were welcome.
McCarthy of the Lee, a slave of late,
McCarthy of Kanturk whose blood
Has dried underfoot:
Of all my princes not a single word –
Irrevocable silence ails my heart,

My heart shrinks in me, my heart ails
That every hawk and royal hawk is lost;
From Cashel to the far sea
Their birthright is dispersed
Far and near, night and day, by robbery
And ransack, every town oppressed.

continued…

Right: The Twelve Bens, Connemara

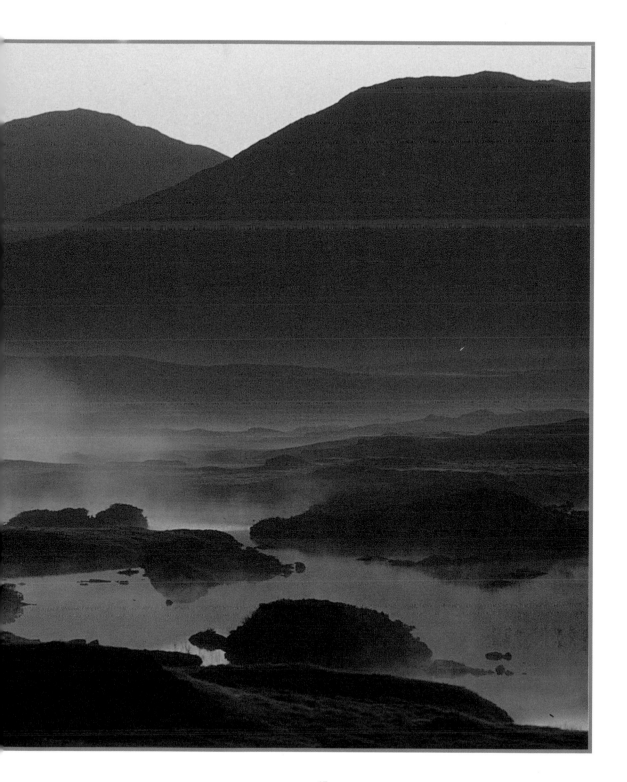

Take warning wave, take warning crown of the sea,
I, O'Rahilly – witless from your discords –
Were Spanish sails again afloat
And rescue on your tides,
Would force this outcry down your wild throat,
Would make you swallow these Atlantic words.

EAVAN BOLAND (1945-)

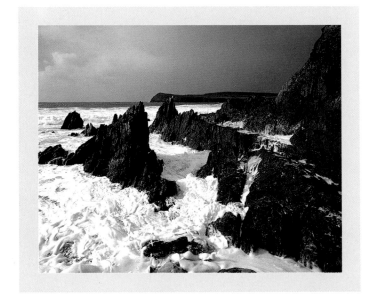

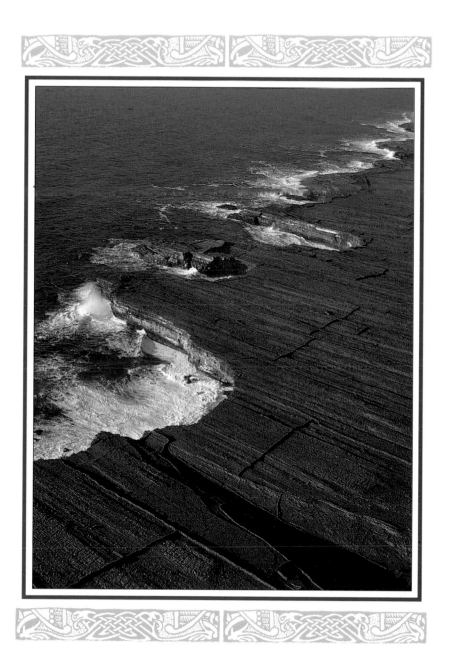

Aran Islands, Co. Galway

IN THE SEVEN WOODS

I have heard the pigeons of the Seven Woods
Make their faint thunder, and the garden bees
 Hum in the lime-tree flowers; and put away
The unavailing outcries and the old bitterness
 That empty the heart. I have forgot awhile
Tara uprooted, and new commonness
 Upon the throne and crying about the streets
And hanging its paper flowers from post to post,
 Because it is alone of all things happy.
I am contented, for I know that Quiet
 Wanders laughing and eating her wild heart
Among pigeons and bees, while that Great Archer,
 Who but awaits His hour to shoot, and still hangs
A cloudy quiver over Pairc-na-lee.

W.B. YEATS (1865-1939)

SHE MOVED THROUGH THE FAIR

My young love said to me, 'My brothers won't mind,
And my parents won't slight you for your lack of kind.'
Then she stepped away from me, and this she did say,
'It will not be long, love, till our wedding day.'

She stepped away from me and she moved through the fair,
And fondly I watched her go here and go there,
Then she went her way homeward with one star awake,
As the swan in the evening moves over the lake.

The people were saying no two were e'er wed
But one had a sorrow that never was said,
And I smiled as she passed with her goods and her gear,
And that was the last that I saw of my dear.

I dreamt it last night that my young love came in,
So softly she entered, her feet made no din;
She came close beside me, and this she did say,
'It will not be long, love, till our wedding day.'

PADRAIC COLUM (1881-1972)

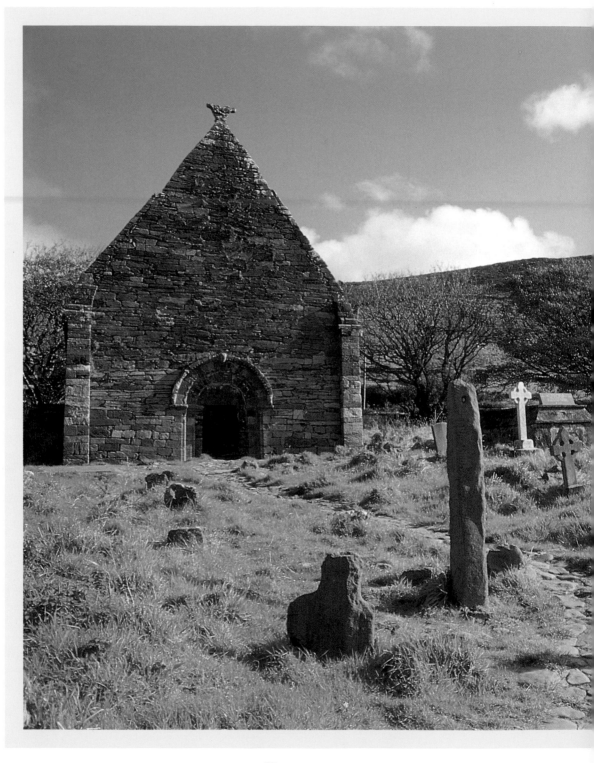

SEPTEMBER 1913

What need you, being come to sense,
But fumble in a greasy till
And add the halfpence to the pence
And prayer to shivering prayer, until
You have dried the marrow from the bone?
For men were born to pray and save:
Romantic Ireland's dead and gone,
It's with O'Leary in the grave.

Yet they were of a different kind,
The names that stilled your childish play,
They have gone about the world like wind,
But little time had they to pray
For whom the hangman's rope was spun,
And what, God help us, could they save?
Romantic Ireland's dead and gone,
It's with O'Leary in the grave.

Was it for this the wild geese spread
The grey wing upon every tide;
For this that all that blood was shed,
For this Edward Fitzgerald died,
And Robert Emmet and Wolfe Tone,
All that delirium of the brave?
Romantic Ireland's dead and gone,
It's with O'Leary in the grave.

Yet could we turn the years again,
And call those exiles as they were
In all their loneliness and pain,
You'd cry, 'Some woman's yellow hair
Has maddened every mother's son':
They weighed so lightly what they gave.
But let them be, they're dead and gone,
They're with O'Leary in the grave.

St Maolcheador's,
Kilmalkedar,
Dingle Peninsula

W.B. YEATS (1865-1939)

REST ONLY IN THE GRAVE

I rode till I reached the House of Wealth—
'Twas filled with riot and blighted health.

I rode till I reached the House of Love—
'Twas vocal with sighs beneath and above!

I rode till I reached the House of Sin—
There were shrieks and curses without and within.

I rode till I reached the House of Toil—
Its inmates had nothing to bake or boil.

I rode in search of the House of Content
But never could reach it, far as I went!

The House of Quiet, for strong and weak
And poor and rich, I have still to seek—

That House is narrow, and dark, and small—
But the only Peaceful House of all.

JAMES CLARENCE MANGAN (1803-1849)

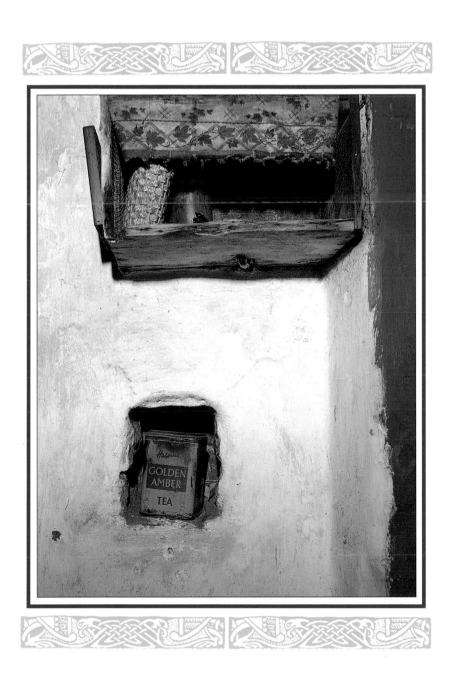

THE DAWNING OF THE DAY

At early dawn I once had been
 Where Lene's blue waters flow,
When summer bid the groves be green,
 The lamp of light to glow.
As on by bower, and town, and tower,
 And widespread fields I stray,
I meet a maid in the greenwood shade
 At the dawning of the day.

Her feet and beauteous head were bare,
 No mantle fair she wore;
But down her waist fell golden hair,
 That swept the tall grass o'er.
With milking-pail she sought the vale,
 And bright her charms' display;
Outshining far the morning star
 At the dawning of the day.

Beside me sat that maid divine
 Where grassy banks outspread.
'Oh, let me call thee ever mine,
 Dear maid,' I sportive said.
'False man, for shame, why bring me blame?'
 She cried, and burst away –
The sun's first light pursued her flight
 At the dawning of the day.

EDWARD WALSH (1805-1851)

Right: Schull, Co. Cork

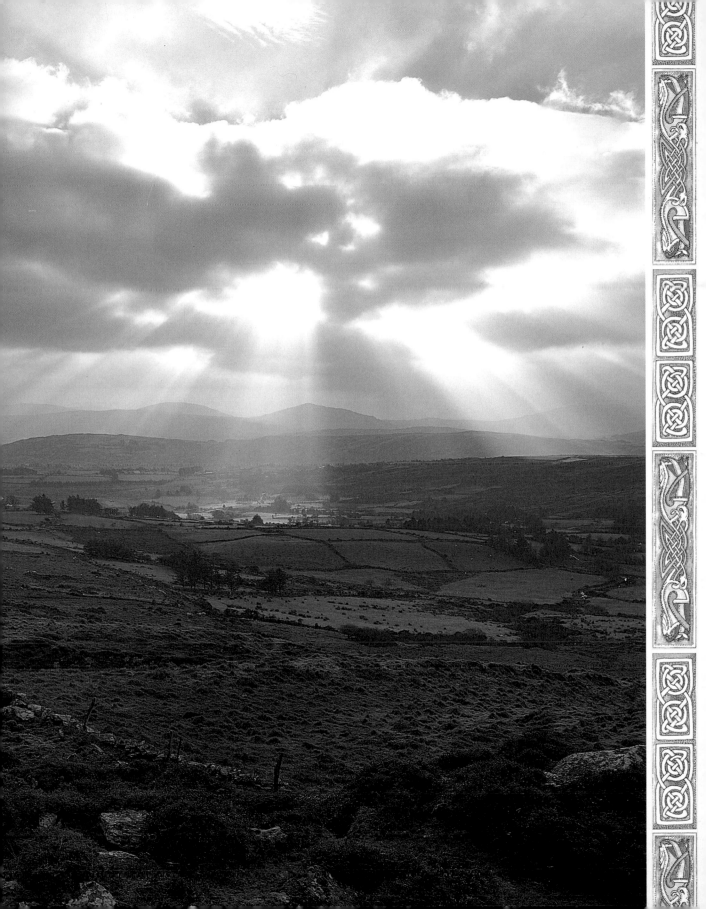

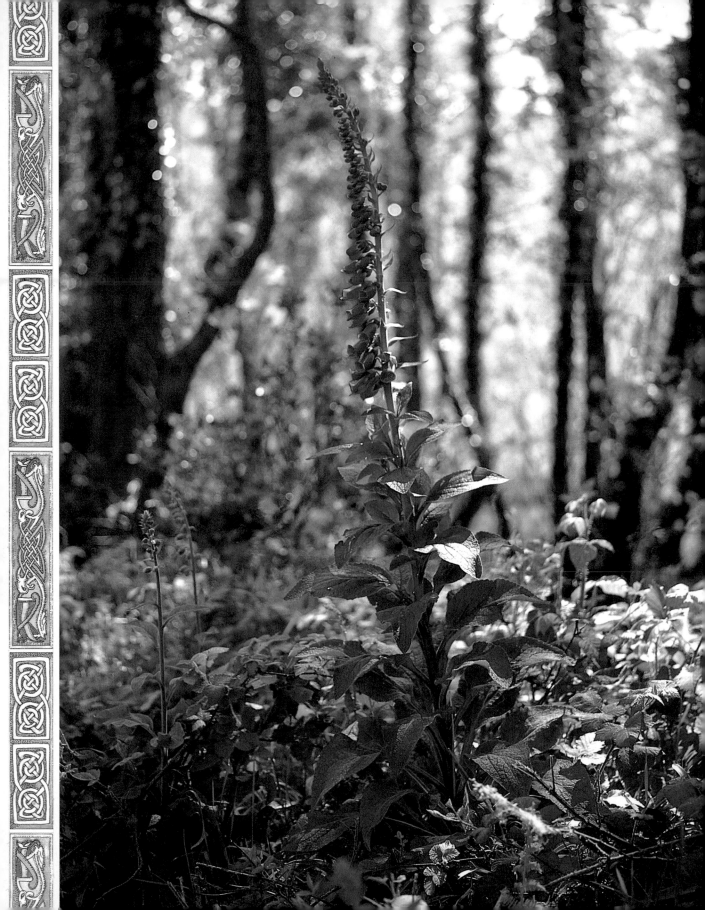

THE DESERTER'S MEDITATION

*I*f sadly thinking, with spirits sinking,
 Could more than drinking my cares compose,
A cure for sorrow from sighs I'd borrow,
 And hope to-morrow would end my woes.
But as in wailing there's nought availing,
 And Death unfailing will strike the blow,
Then for that reason, and for a season,
 Let us be merry before we go.

To joy a stranger, a way-worn ranger,
 In every danger my course I've run;
Now hope all ending, and death befriending
 His last aid lending, my cares are done.
No more a rover, or hapless lover,
 My griefs are over – my glass runs low;
Then for that reason, and for a season,
 Let us be merry before we go.

JOHN PHILPOT CURRAN (1750-1817)

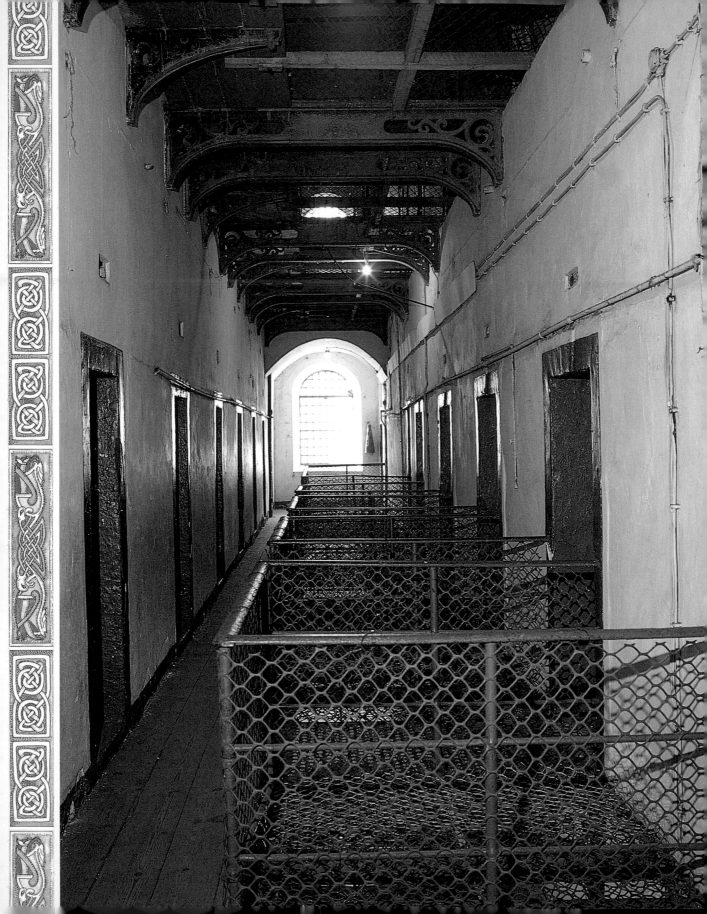

THE MEMORY OF THE DEAD

Who fears to speak of Ninety-Eight?
　　Who blushes at the name?
When cowards mock the patriot's fate
　　Who hangs his head for shame?
He's all a knave or half a slave
　　Who slights his country thus:
But a true man, like you, man,
　　Will fill your glass with us.

We drink the memory of the brave,
　　The faithful and the few –
Some lie far off beyond the wave,
　　Some sleep in Ireland, too;
All, all are gone – but still lives on
　　The fame of those who died;
And true men, like you, men
　　Remember them with pride.

Some on the shores of distant lands
　　Their weary hearts have laid,
And by the stranger's heedless hands
　　Their lonely graves were made;
But though their clay be far away
　　Beyond the Atlantic foam,
In true men, like you, men
　　Their spirit's still at home.

The dust of some is Irish earth;
　　Among their own they rest;
And the same land that gave them birth
　　Has caught them to her breast;
And we will pray that from their clay
　　Full many a race may start
Of true men, like you, men,
　　To act as brave a part.

They rose in dark and evil days
　　To right their native land;
They kindled here a living blaze
　　That nothing shall withstand.
Alas! that Might can vanquish Right –
　　They fell, and passed away;
But true men, like you, men,
　　Are plenty here today.

Then here's their memory – may it be
　　For us a guiding light,
To cheer our strife for liberty,
　　And teach us to unite!
Through good and ill, be Ireland's still,
　　Though sad as theirs, your fate;
And true men, be you, men,
　　Like those of Ninety-Eight.

JOHN KELLS INGRAM (1823-1907)

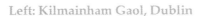

Left: Kilmainham Gaol, Dublin

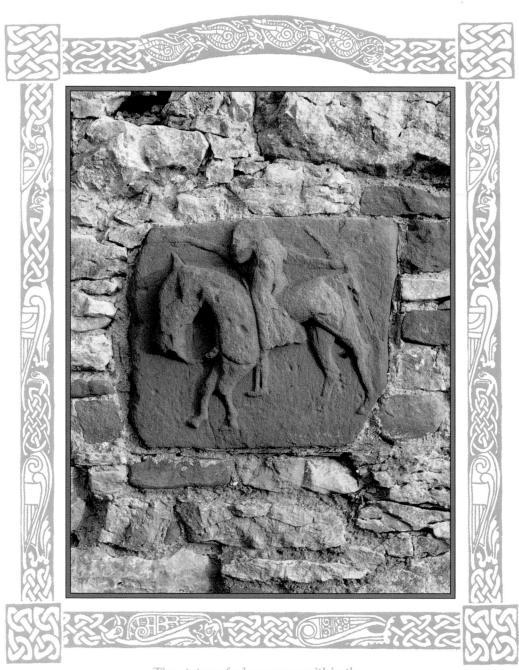

The statue of a horseman within the
ruins of a church at Annagh, Tralee

A VISION OF CONNAUGHT
IN THE THIRTEENTH CENTURY

I walked entranced
　　Through a land of Morn;
The sun, with wondrous excess of light,
　　Shone down and glanced
　　Over seas of corn
And lustrous gardens aleft and right.
　　Even in the clime
　　Of resplendent Spain,
Beams no such sun upon such a land;
　　But it was the time,
　　'Twas in the reign,
Of Cáhal Mór of the Wine-red Hand.

　　Anon stood nigh
　　By my side a man
Of princely aspect and port sublime.
　　Him queried I –
　　'O, my Lord and Khan,
What clime is this, and what golden time?'
　　When he – 'The clime
　　Is a clime to praise,
The clime is Erin's, the green and bland;
　　And it is the time,
　　These be the days,
Of Cáhal Mór of the Wine-red Hand!'

　　Then I saw the thrones,
　　And circling fires,
And a Dome rose near me, as by a spell,
　　Whence flowed the tones
　　Of silver lyres,
And many voices in wreathéd swell;
　　And their thrilling chime
　　Fell on mine ears
As the heavenly hymn of an angel-band –
　　'It is now the time,
　　These be the years,
Of Cáhal Mór of the Wine-red Hand!'

　　I sought the hall,
　　And, behold! – a change
From light to darkness, from joy to woe!
　　King, nobles, all,
　　Looked aghast and strange;
The minstrel-group sate in dumbest show!
　　Had some great crime
　　Wrought this dread amaze,
This terror? None seemed to understand
　　'Twas then the time,
　　We were in the days,
Of Cáhal Mór of the Wine-red Hand.

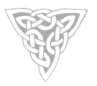

continued...

I again walked forth;
But lo! the sky
Showed fleckt with blood, and an alien sun
Glared from the north
And there stood on high,
Amid his shorn beams, a skeleton!
It was by the stream
Of the castled Maine,
One Autumn eve, in the Teuton's land,
That I dreamed this dream
Of the time and reign
Of Cáhal Mór of the Wine-red Hand!

JAMES CLARENCE MANGAN (1803-1849)

The tomb of Strongbow in Christ
Church Cathedral, Dublin

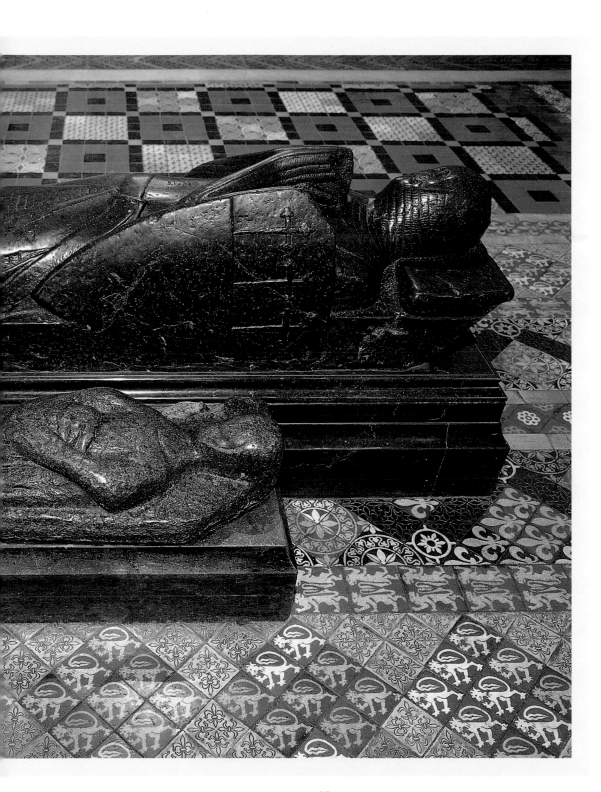

THE BELLS OF SHANDON

With deep affection and recollection
 I often think of the Shandon bells,
Whose sounds so wild would, in days of childhood,
 Fling round my cradle their magic spells.
On this I ponder, where'er I wander
 And thus grow fonder, sweet Cork, of thee;
 With thy bells of Shandon,
 That sound so grand on
 The pleasant waters of the river Lee.

I have heard bells chiming full many a clime in,
 Tolling sublime in cathedral shrine;
While at a glib rate brass tongues would vibrate,
 But all their music spoke nought to thine;
For memory dwelling on each proud swelling
 Of thy belfry knelling its bold notes free,
 Made the bells of Shandon
 Sound far more grand on
 The pleasant waters of the river Lee.

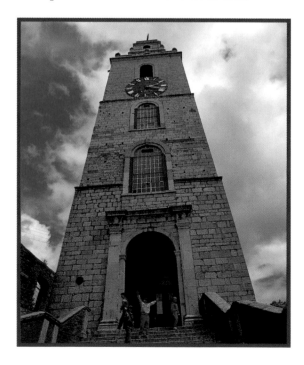

The church of
St Anne's, Shandon,
Cork City

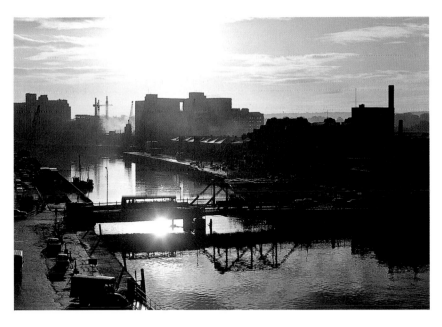

The River Lee, Cork City

I have heard bells tolling 'old Adrian's mole' in,
Their thunder rolling from the Vatican,
With cymbals glorious, swinging uproarious
In the gorgeous turrets of Notre Dame;
But thy sounds were sweeter than the dome of Peter
Flings o'er the Tiber, pealing solemnly.
Oh! the bells of Shandon
Sound far more grand on
The pleasant waters of the river Lee.

There's a bell in Moscow, while on tower and kiosko
In St Sophia the Turkman gets,
And loud in air calls men to prayer
From the tapering summit of tall minarets.
Such empty phantom I freely grant 'em,
But there's an anthem more dear to me:
'Tis the bells of Shandon,
That sound so grand on
The pleasant waters of the river Lee.

FRANCIS SYLVESTER MAHONY (1804-1866)

SNOW

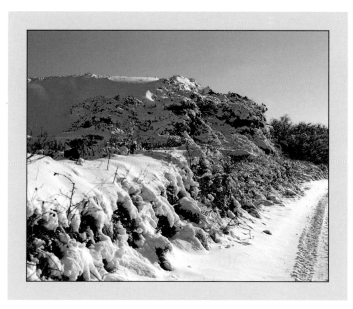

The room was suddenly rich and the great bay-window was
　　Spawning snow and pink roses against it
　　Soundlessly collateral and incompatible:
　　World is suddener than we fancy it.

　　World is crazier and more of it than we think,
　　　Incorrigibly plural. I peel and portion
　　　A tangerine and spit the pips and feel
　　　The drunkenness of things being various.

　　And the fire flames with a bubbling sound for world
　　Is more spiteful and gay than one supposes –
　　On the tongue on the eyes on the ears in the palms of one's hands –
　　There is more than glass between the snow and the huge roses.

LOUIS MACNEICE (1907-1963)

'NOW, WINTER'S DOLOROUS DAYS ARE O'ER'

*N*ow, winter's dolorous days are o'er, and through
March morning casements comes the sharp spring air,
And noises from the distant city, where
The steeples stand up keenly in the blue:
No more the clouds by crispy frost defined,
Pile the pale North, but float, dispersed shapes;
Though still around the cool grey twilight capes,
The sullen sea is dark with drifts of wind.
Like a forgotten fleck of snow still left,
The cascade gleams in the far mountain cleft;
Brown rushes by the river's brimming bank
Rustle, and matted sedges sway and sigh,
Where grasses in sleek shallows waver dank,
Or drift in windy ripples greyly by.

THOMAS CAULFIELD IRWIN (1823-1892)

Right: Muckross Lake, Co. Kerry

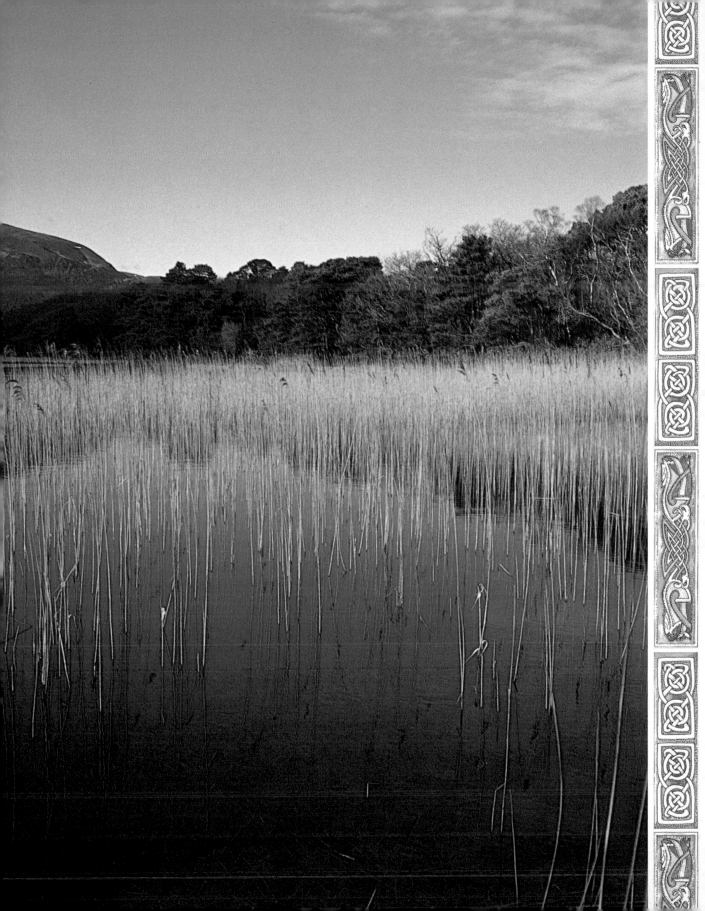

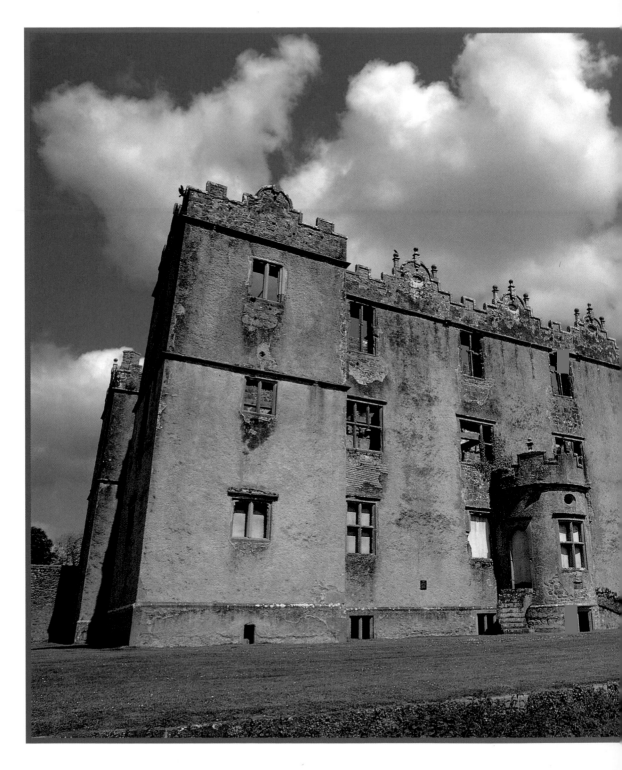

THE WOODS

*T*wo years we spent
 down there, in a quaint
 outbuilding bright with recent paint.

A green retreat,
 secluded and sedate,
 part of a once great estate,

it watched our old
 bone-shaker as it growled
 with guests and groceries through heat and cold,

and heard you tocsin
 meal-times with a spoon
 while I sat working in the sun.

Above the yard
 an old clock had expired
 the night Lenin arrived in Petrograd.

Bourbons and Romanovs
 had removed their gloves
 in the drawing-rooms and alcoves

of the manor house;
 but these illustrious
 ghosts never imposed on us.

Enough that the pond
 steamed, the apples ripened,
 the conkers on the gravel opened.

continued…

Left: Portumna Castle, Co. Galway

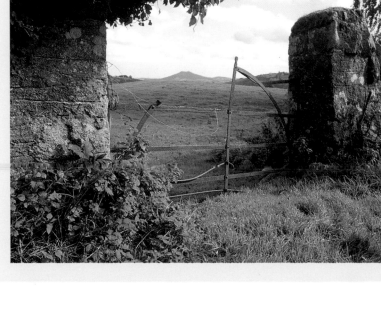

Ragwort and hemlock,
cinquefoil and ladysmock
throve in the shadows at the back;

beneath the trees
foxgloves and wood anemones
looked up with tearful metamorphic eyes.

We woke the rooks
on narrow, winding walks
familiar from the story books,

or visited
a disused garden shed
where gas-masks from the war decayed;

and we knew peace
splintering the thin ice
on the bath-tub drinking-trough for cows.

But how could we
survive indefinitely
so far from the city and the sea?

Finding, at last,
too creamy for our taste
the fat profusion of that feast,

we travelled on
to doubt and speculation,
our birthright and our proper portion.

Another light
than ours convenes the mute
attention of those woods tonight –

while we, released
from that pale paradise,
ponder the darkness in another place.

DEREK MAHON (1941-)

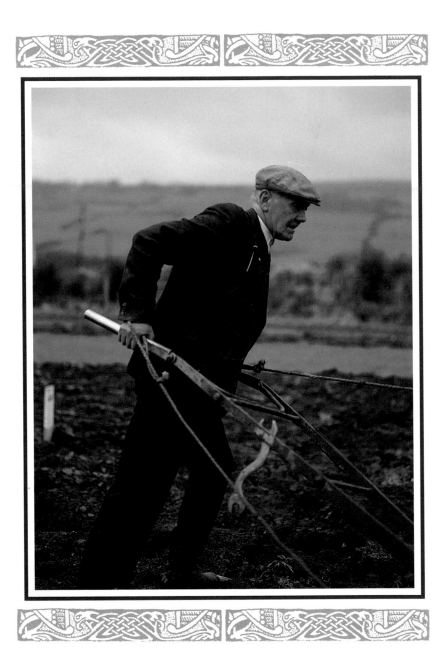

PLOUGHER

*S*unset and silence! A man; around him earth savage, earth
 broken;
Beside him two horses, a plough!

Earth savage, earth broken, the brutes, the dawn-man there
 in the sunset,
And the plough that is twin to the sword, that is founder of
 cities!

'Brute-tamer, plough-maker, earth-breaker! Canst hear?
 There are ages between us –
Is it praying you are as you stand there alone in the sunset?

Surely our sky-born gods can be naught to you, earth-child
 and earth-master –
Surely your thoughts are of Pan, or of Wotan, or Dana?

Yet why give thought to the gods? Has Pan led your brutes
 where they stumble?
Has Dana numbed pain of the child-bed, or Wotan put hand
 to your plough?

What matter your foolish reply? O man standing lone and
 bowed earthward,
Your task is a day near its close. Give thanks to the night-
 giving god.'

Slowly the darkness falls, the broken lands blend with the
 savage;
The brute-tamer stands by the brutes, a head's breadth only
 above them.

A head's breadth? Aye, but therein is hell's depth and the
 height up to heaven,
And the thrones of the gods and their halls, their chariots,
 purples, and splendours.

PADRAIC COLUM (1881-1972)

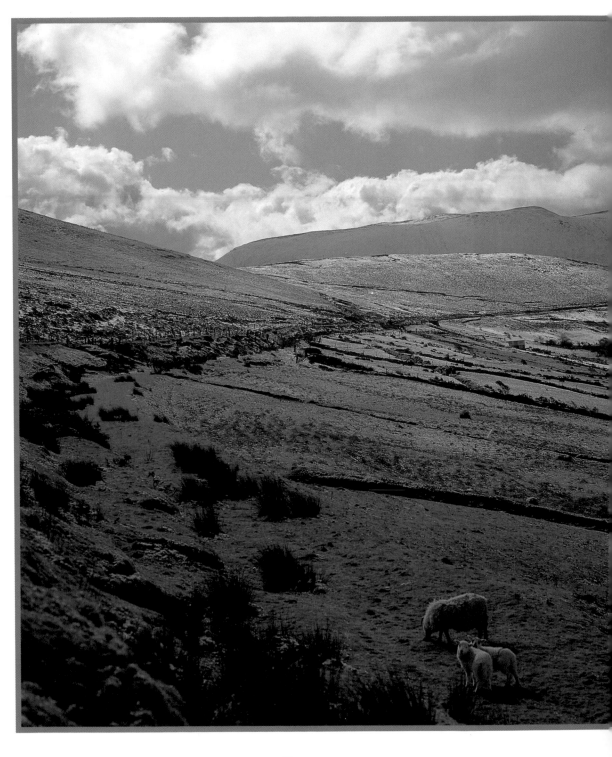

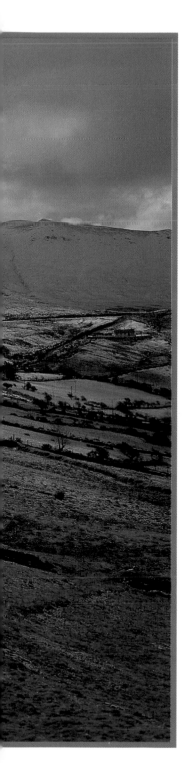

DO YOU REMEMBER THAT NIGHT?

Do you remember that night
When you were at the window
With neither hat nor gloves
Nor coat to shelter you?
I reached out my hand to you
And you ardently grasped it,
I remained to converse with you
Until the lark began to sing.

Beloved of my inmost heart,
Come some night, and soon,
When my people are at rest,
That we may talk together.
My arms shall encircle you
While I relate my sad tale,
That your soft, pleasant converse
Hath deprived me of heaven.

Do you remember that night
That you and I were
At the foot of the rowan-tree
And the night drifting snow?
Your head on my breast,
And your pipe sweetly playing?
Little thought I that night
That our love ties would loosen!

The fire is unraked,
The light unextinguished,
The key under the door,
Do you softly draw it.
My mother is asleep,
But I am wide awake;
My fortune in my hand,
I am ready to go with you.

EUGENE O'CURRY (1796-1862)

Left: Winter snow on the
Dingle Peninsula

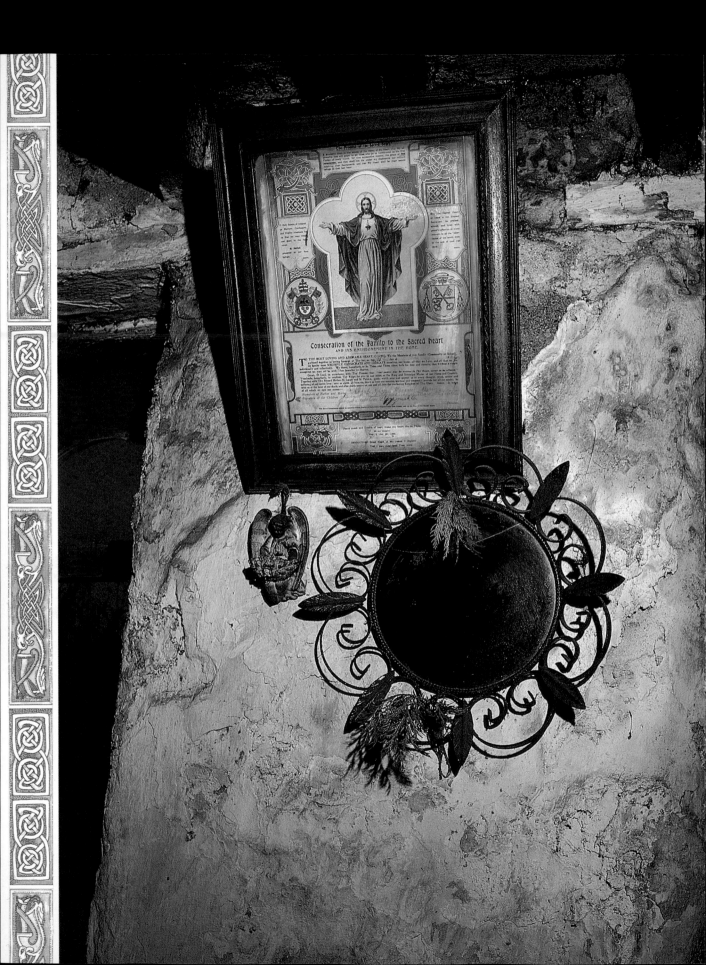

THE STRAYING STUDENT

*O*n a holy day when sails were blowing southward,
A bishop sang the Mass at Inishmore,
Men took one side, their wives were on the other
But I heard the woman coming from the shore:
And wild in despair my parents cried aloud
For they saw the vision draw me to the doorway.

Long had she lived in Rome when Popes were bad,
The wealth of every age she makes her own,
Yet smiled on me in eager admiration,
And for a summer taught me all I know,
Banishing shame with that great laugh that rang
As if a pillar caught it back alone.

I learned the prouder counsel of her throat,
My mind was growing bold as light in Greece;
And when in sleep her stirring limbs were shown,
I blessed the noonday rock that knew no tree:
And for an hour the mountain was her throne,
Although her eyes were bright with mockery.

They say I was sent back from Salamanca
And failed in logic, but I wrote her praise
Nine times upon a college wall in France.
She laid her hand at darkfall on my page
That I might read the heavens in a glance
And I knew every star the Moors have named.

Awake or in my sleep, I have no peace now,
Before the ball is struck, my breath has gone,
And yet I tremble lest she may deceive me
And leave me in this land, where every woman's son
Must carry his own coffin and believe,
In dread, all that the clergy teach the young.

AUSTIN CLARKE (1896-1974)

101

WHEN YOU ARE OLD

When you are old and grey and full of sleep,
And nodding by the fire, take down this book,
And slowly read, and dream of the soft look
Your eyes had once, and of their shadows deep;

How many loved your moments of glad grace,
And loved your beauty with love false or true,
But one man loved the pilgrim soul in you,
And loved the sorrows of your changing face;

And bending down beside the glowing bars,
Murmur, a little sadly, how Love fled
And paced upon the mountains overhead
And hid his face amid a crowd of stars.

W.B. YEATS (1865-1939)

BOGLAND

for T.P. Flanagan

We have no prairies
 To slice a big sun at evening –
Everywhere the eye concedes to
 Encroaching horizon,

Is wooed into the cyclops' eye
 O a tarn. Our unfenced country
Is bog that keeps crusting
 Between the sights of the sun.

They've taken the skeleton
 Of the Great Irish Elk
Out of the peat, set it up
 An astounding crate full of air.

Butter sunk under
 More than a hundred years
Was recovered salty and white.
 The ground itself is kind, black butter

Melting and opening underfoot,
 Missing its last definition
By millions of years.
 They'll never dig coal here,

Only the waterlogged trunks
 Of great firs, soft as pulp.
Our pioneers keep striking
 Inwards and downwards,

Every layer they strip
 Seems camped on before.
The bogholes might be Atlantic seepage.
 The wet centre is bottomless.

SEAMUS HEANEY (1939-)

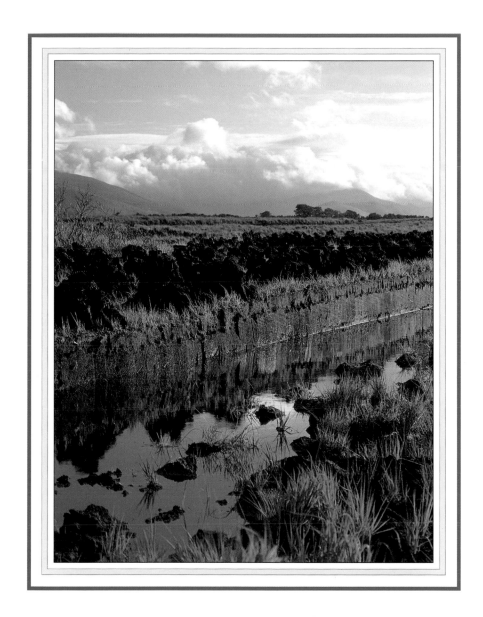

CANAL BANK WALK

Leafy-with-love banks and the green waters of the canal
Pouring redemption for me, that I do
The will of God, wallow in the habitual, the banal,
Grow with nature again as before I grew.
The bright stick trapped, the breeze adding a third
Party to the couple kissing on an old seat,
And a bird gathering materials for a nest for the Word
Eloquently new and abandoned to its delirious beat.
O unworn world enrapture me, encapture me in a web
Of fabulous grass and eternal voices by a beech,
Feed the gaping need of my senses, give me ad lib
To pray unselfconsciously with overflowing speech
For this soul needs to be honoured with a new dress woven
From green and blue things and arguments that cannot be proven

PATRICK KAVANAGH (1904-1967)

The Grand Canal, Dublin

THE VILLAGE

*S*weet was the sound, when oft at evening's close
Up yonder hill the village murmur rose;
 There, as I passed with careless steps and slow,
 The mingling notes came soften'd from below:
The swain responsive as the milkmaid sung,
The sober herd that low'd to meet their young;
 The noisy geese that gabbled o'er the pool,
 The playful children just let loose from school;
The watchdog's voice that bay'd the whisp'ring wind,
And the loud laugh that spoke the vacant mind;
 These all in sweet confusion sought the shade,
 And fill'd each pause the nightingale had made.
But now the sounds of population fail,
No cheerful murmurs fluctuate in the gale,
 No busy steps the grass-grown footway tread,
 For all the bloomy flush of life is fled.
All but yon widow'd, solitary thing,
That feebly bends beside the plashy spring:
 She, wretched matron, forc'd in age, for bread,
 To strip the brook with mantling cresses spread,
To strip her wintry faggot from the thorn,
To seek her nightly shed, and weep till morn;
 She only left of all the harmless train,
 The sad historian of the pensive plain.

OLIVER GOLDSMITH (1728-1774)

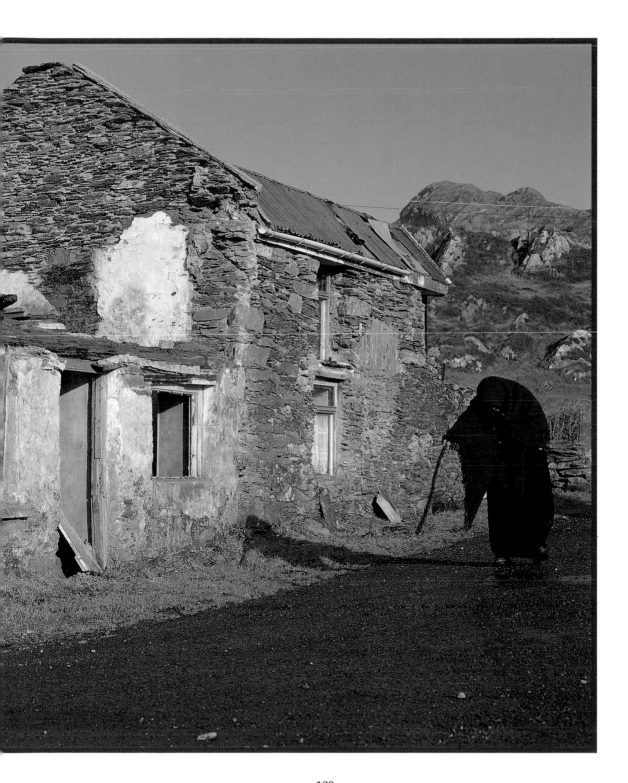

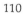

BACKSIDE TO THE WIND

A fourteen-year-old boy is out rambling alone
By the scimitar shores of Killala Bay
And he is dreaming of a French Ireland,
Backside to the wind.

What kind of village would I now be living in?
French vocabularies intertwined with Gaelic
And Irish women with French fathers,
Backsides to the wind.

The Ballina Road would become the Rue de Humbert
And wine would be the staple drink of the people;
A staple diet of potatoes and wine,
Backsides to the wind.

Monsieur O'Duffy might be the harbour-master
And Madame Duffy the mother of thirteen
Tiny philosophers to overthrow Maynooth,
Backsides to the wind.

Father Molloy might be a worker-priest
Up to his knees in manure at the cattle-mart;
And dancing and loving on the streets at evening
Backsides to the wind.

Jean Arthur Rimbaud might have grown up here
In a hillside terrace under the round tower;
Would he, like me, have dreamed of an Arabian Dublin,
Backside to the wind?

Garda Ned MacHale might now be a gendarme
Having hysterics at the crossroads;
Excommunicating male motorists, ogling females,
Backside to the wind.

continued…

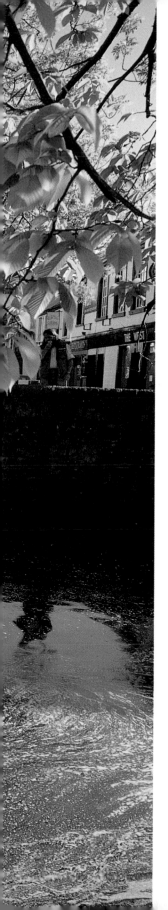

I walk on, facing the village ahead of me,
A small concrete oasis in the wild countryside;
Not the embodiment of the dream of a boy,
Backside to the wind.

Seagulls and crows, priests and nuns,
Perch on the rooftops and steeples,
And their Anglo-American mores asphyxiate me,
Backside to the wind.

Not to mention the Japanese invasion:
Blunt people as serious as ourselves
And as humourless; money is our God,
Backsides to the wind.

The medieval Franciscan Friary of Moyne
Stands house-high, roofless, by;
Past it rolls a vast asphalt pipe,
Backsides to the wind,

Ferrying chemical waste out to sea
From the Asahi synthetic-fibre plant;
Where once monks sang, wage-earners slave,
Backsides to the wind.

Run on, sweet River Moy,
Although I end my song; you are
The scales of a salmon of a boy,
Backside to the wind.

Yet I have no choice but to leave, to leave,
And yet there is nowhere I more yearn to live
Than in my own wild countryside,
Backside to the wind.

PAUL DURCAN (1944-)

HIGH ISLAND

A shoulder of rock
Sticks high up out of the sea,
A fisherman's mark
For lobster and blue-shark.

 Fissile and stark
 The crust is flaking off,
 Seal-rock, gull-rock,
 Cove and cliff.

Dark mounds of mica schist,
A lake, mill and chapel,
Roofless, one gable smashed,
Lie ringed with rubble.

 An older calm,
 The kiss of rock and grass,
 Pink thrift and white sea-campion,
 Flowers in the dead place.

Day keeps lit a flare
Round the north pole all night
Like brushing long wavy hair
Petrels quiver in flight.

 Quietly as the rustle
 Of an arm entering a sleeve,
 They slip down to nest
 Under altar-stone or grave.

Round the wrecked laura
Needles flicker
Tacking air, quicker and quicker
To rock, sea and star.

RICHARD MURPHY (1927-)

Right: Grainnes
Wails Castle,
Achill Island

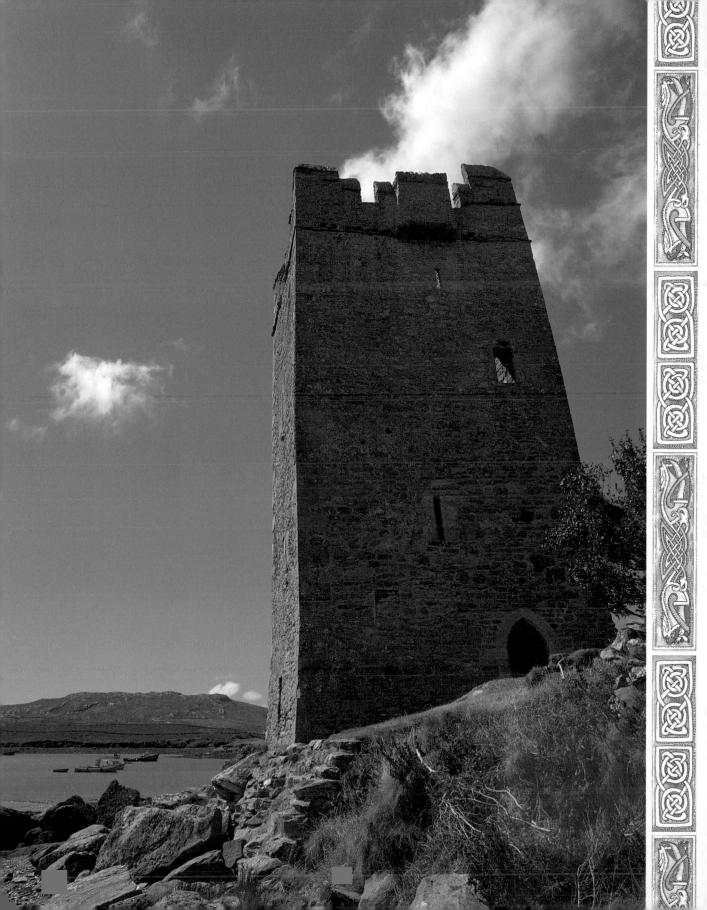

THE SWIMMER

For him the Shannon opens
Like a woman.
He has stepped over the stones

And cut the water
With his body
But this river does not bleed for

Any man. How easily
He mounts the waves, riding them
As though they

Whispered subtle invitations to his skin,
Conspiring with the sun
To offer him

A white, wet rhythm. The deep beneath
Gives full support
To the marriage of wave and heart,

The waves he breaks turn back to stare
At the repeated ceremony
And the hills of Clare

Witness the fluent weddings
The flawless congregation
The choiring foam that sings

To limbs which must, once more,
Rising and falling in the sun,
Return to shore.

Again he walks upon the stones,
A new music in his heart,
A river in his bones

Flowing forever through his head
Private as a grave
Or as the bridal bed.

BRENDAN KENNELLY (1936-)

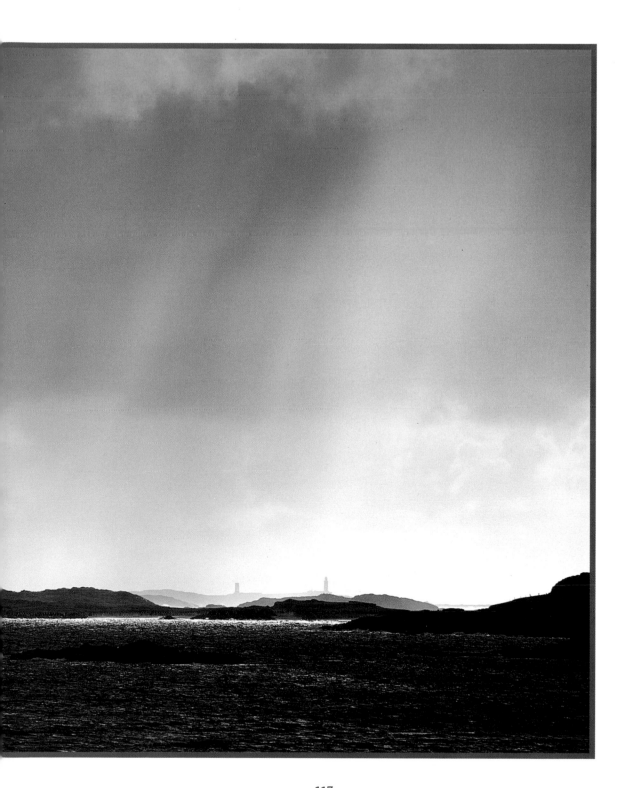

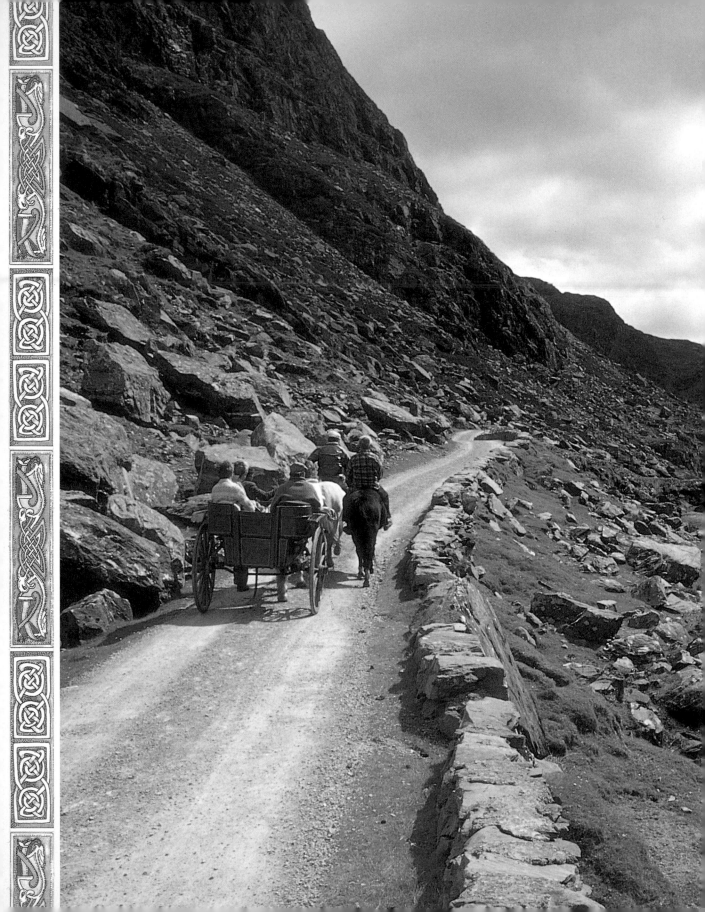

BIRTH OF A COACHMAN

*H*is father and grandfather before him were coachmen:
How strange, then, to think that this small, bloody, lump of flesh,
 This tiny moneybags of brains, veins, and intestines,
This zipped-up purse of most peculiar coin,
 Will one day be coachman of the Cork to Dublin route,
In a great black greatcoat and white gauntlets,
 In full command of one of our famous coaches
Wonder, Perseverance, Diligence, or Lightning –
 In charge of all our lives on foul winter nights,
Crackling his whip, whirling it, lashing it,
 Driving on the hapless horses across the moors
Of the Kilworth hills, beating them on
 Across rivers in spate, rounding sharp bends
On only two wheels, shrieking of axle-trees,
 Rock-scrapes, rut-squeals, quagmire-squelches,
For ever in dread of the pitiless highwayman
 Lurking in ambush with a brace of pistols;
Then cantering carefully in the lee of the Galtees,
 Bowing his head to the stone gods of Cashel;
Then again thrusting through Urlingford;
 Doing his bit, and his nut, past the Devilsbit;
Praising the breasts of the hills round Port Laoise;
 Sailing full furrow through the Curragh of Kildare,
Through the thousand sea-daisies of a thousand white sheep;
 Thrashing gaily the air at first glimpse of the Liffey;
Until stepping down from his high perch in Dublin
 Into the sanctuary of a cobbled courtyard,
Into the arms of a crowd like a triumphant toreador
 All sweat and tears: the man of the moment
Who now is but a small body of but some fleeting seconds old.

PAUL DURCAN (1944-)

Left: The Gap of Dunloe, Co. Kerry

119

MY DARK FATHERS

My dark fathers lived the intolerable day
Committed always to the night of wrong,
 Stiffened at the heartstone, the woman lay,
 Perished feet nailed to her man's breastbone.
Grim houses beckoned in the swelling gloom
Of Munster fields where the Atlantic night
 Fettered the child within the pit of doom,
 And everywhere a going down of light.

And yet upon the sandy Kerry shore
The woman once had danced at ebbing tide
 Because she loved flute music – and still more
 Because a lady wondered at the pride
Of one so humble. That was long before
The green plants withered by an evil chance;
 When winds of hunger howled at every door
 She heard the music dwindle and forgot the dance.

Such mercy as the wolf receives was hers
Whose dance became a rhythm in a grave,
 Achieved beneath the thorny savage furze
 That yellowed fiercely in a mountain cave.
Immune to pity, she, whose crime was love,
Crouched, shivered, searched the threatening sky,
 Discovered ready signs, compelled to move
 Her to her innocent appalling cry.

continued...

Inch Beach,
Co. Kerry

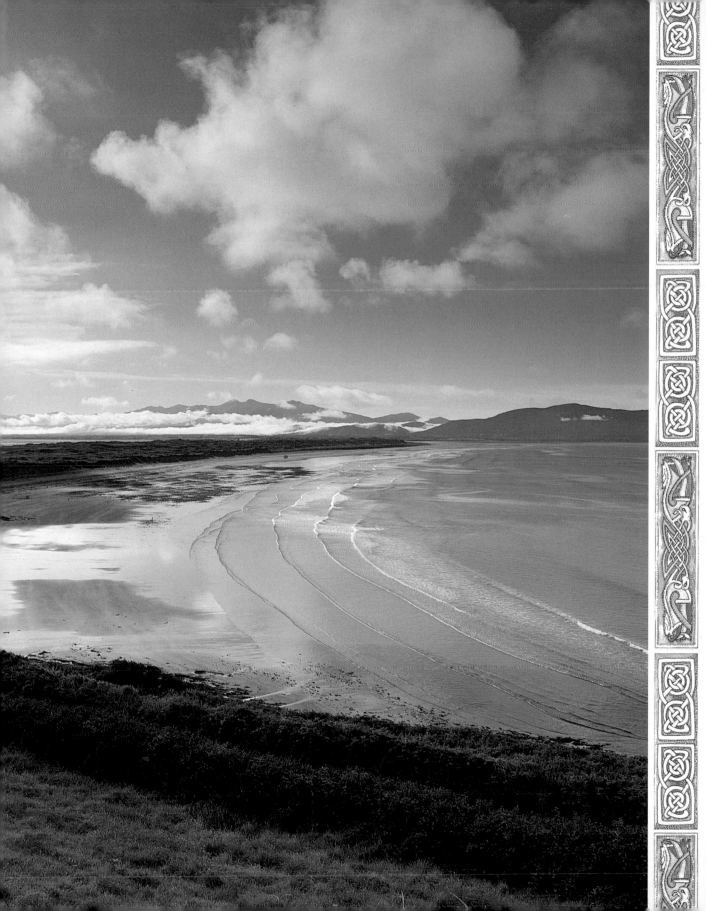

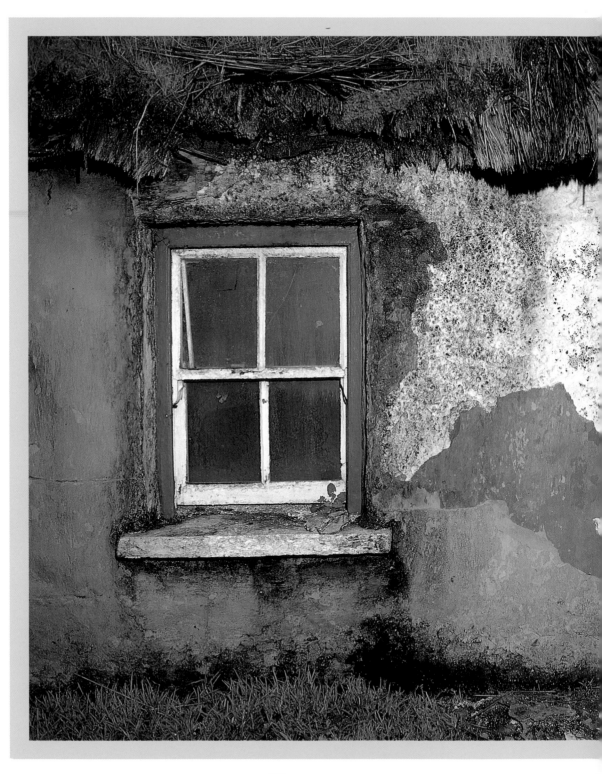

Skeletoned in darkness, my dark fathers lay
Unknown, and could not understand
 The giant grief that trampled night and day,
 The awful absence moping through the land.
Upon the headland, the encroaching sea
Left sand that hardened after tides of Spring,
 No dancing feet disturbed its symmetry
 And those who loved good music ceased to sing.

Since every moment of the clock
Accumulates to form a final name,
 Since I am come of Kerry clay and rock,
 I celebrate the darkness and the shame
That could compel a man to turn his face
Against the wall, withdrawn from light so strong
 And undeceiving, spancelled in a place
 Of unapplauding hands and broken song.

BRENDAN KENNELLY (1936-)

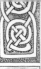

THE MEETING OF THE WATERS

*T*here is not in the wide world a valley so sweet
 As that vale in whose bosom the bright waters meet;
Oh! the last rays of feeling and life must depart,
 Ere the bloom of that valley shall fade from my heart.

 Yet it *was* not that Nature had shed o'er the scene
 Her purest of crystal and brightest of green;
 'Twas *not* her soft magic of streamlet or hill,
 Oh! no, – it was something more exquisite still.

'Twas that friends, the belov'd of my bosom, were near,
 Who made every dear scene of enchantment more dear,
And who felt how the best charms of nature improve,
 When we see them reflected from looks that we love.

 Sweet vale of Avoca! how calm could I rest
 In thy bosom of shade, with the friends I love best,
 Where the storms that we feel in this cold world should cease,
 And our hearts, like thy waters, be mingled in peace.

THOMAS MOORE (1779-1852)

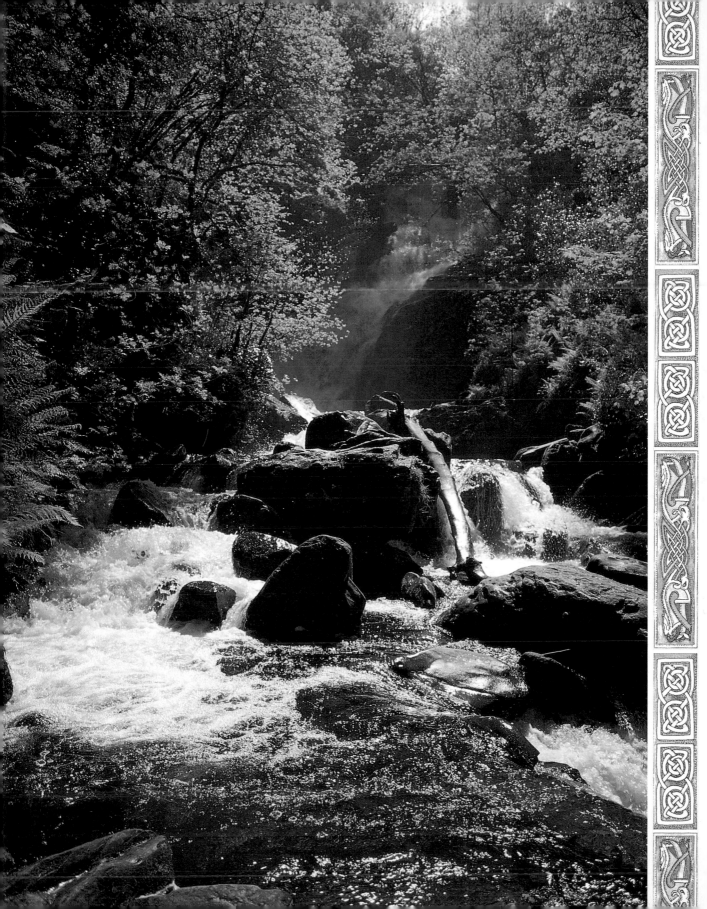

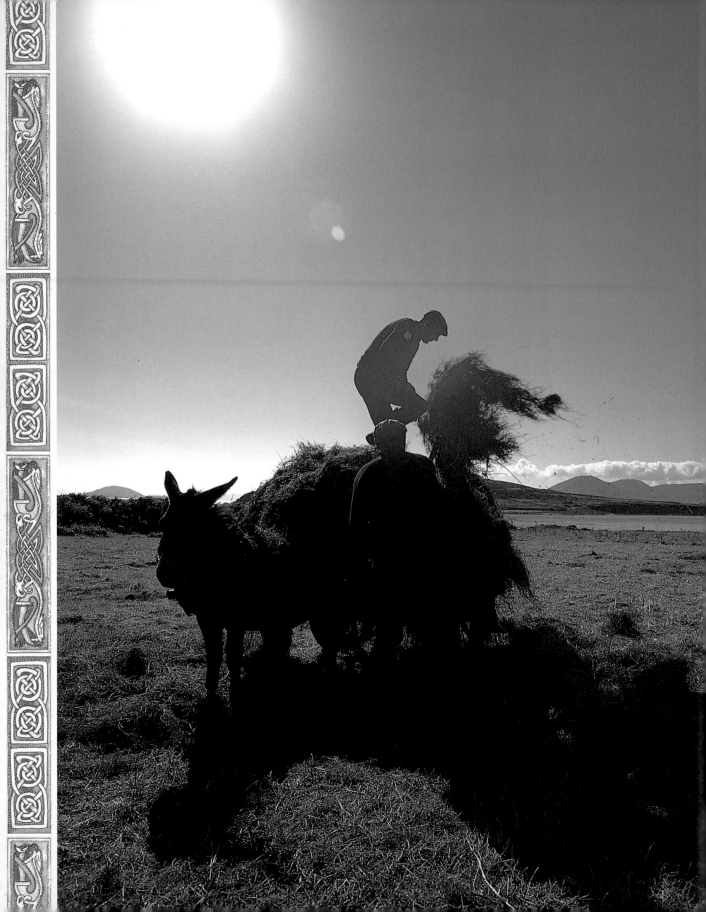

GATHERING MUSHROOMS

*T*he rain comes flapping through the yard
like a tablecloth that she hand-embroidered.
My mother has left it on the line.
It is sodden with rain,
The mushroom shed is windowless, wide,
its high-stacked mushroom trays
hosed down with formaldehyde.
And my father has opened the Gates of Troy
to that first load of horse manure.
Barley straw. Gypsum. Dried blood. Ammonia.
Wagon after wagon
blusters in, a self-renewing gold-black dragon
we push to the back of the mind.
We have taken our pitchforks to the wind.

All brought back to me that September evening
fifteen years on. The pair of us
tripping through Barnett's fair demesne
like girls in long dresses
after a hail-storm.
We might have been thinking of the fire-bomb
that sent Malone House sky-high
and its priceless collection of linen
sky-high.
We might have wept with Elizabeth McCrum.
We were thinking only of psilocobyn.
You sang of the maid you met on the dewy grass –
And she stooped so low gave me to know
it was mushrooms she was gathering O.

continued…

He'll be wearing that same old donkey-jacket
and the sawn-off waders.
He carries a knife, two punnets, a bucket.
He reaches far into his own shadow.
We'll have taken him unawares
and stand behind him, slightly to one side.
He is one of those ancient warriors
before the rising tide.
He'll glance back from under his peaked cap
without breaking rhythm:
his coaxing a mushroom – a flat or a cup –
the nick against his right thumb;
the bucket then, the punnet to left or right,
and so on and so forth till kingdom come.

We followed the overgrown tow-path by the Lagan.
The sunset would deepen through cinnamon
to aubergine,
the wood-pigeon's concerto for oboe and strings,
allegro, blowing your mind.
And you were suddenly out of my ken, hurtling
towards the ever-receding ground,
into the maw
of a shimmering green-gold dragon.
You discovered yourself in some outbuilding
with your long-lost companion, me,
though my head had grown into the head of a horse
that shook its dirty-fair mane
and spoke this verse:

Come back to us. However cold and raw, your feet
were always meant
to negotiate terms with bare cement.
Beyond this concrete wall is a wall of concrete
and barbed wire. Your only hope
is to come back. If sing you must, let your song
tell of treading your own dung,
let straw and dung give a spring to your step.
If we never live to see the day we leap
into our true domain,
lie down with us now and wrap
yourself in the soiled grey blanket of Irish rain
that will, one day, bleach itself white.
Lie down with us and wait.

(PAUL MULDOON 1951-)

LINES WRITTEN ON A SEAT ON THE GRAND CANAL, DUBLIN, 'ERECTED TO THE MEMORY OF MRS DERMOT O'BRIEN'

O commemorate me where there is water,
Canal water preferably, so stilly
Greeny at the heart of summer. Brother
Commemorate me thus beautifully
Where by a lock Niagarously roars
The falls for those who sit in the tremendous silence
Of mid-July. No one will speak in prose
Who finds his way to these Parnassian islands.
A swan goes by head low with many apologies,
Fantastic light looks through the eyes of bridges –
And look! a barge comes bringing from Athy
And other far-flung towns mythologies.
O commemorate me with no hero-courageous
Tomb – just a canal-bank seat for the passer-by.

PATRICK KAVANAGH (1904-1967)

Right: The Grand Canal, Dublin

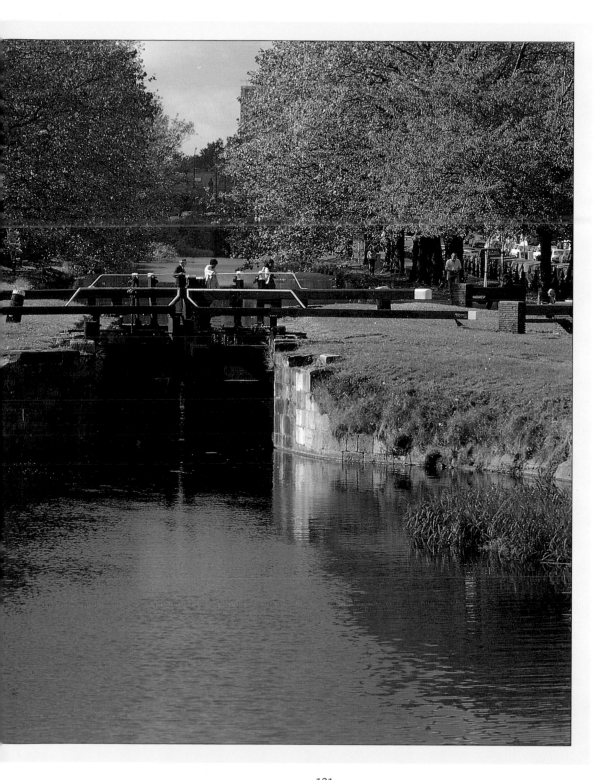

I SAW FROM THE BEACH

I saw from the beach, when the morning was shining,
 A bark o'er the waters move gloriously on;
I came when the sun from that beach was declining,
 The bark was still there, but the waters were gone.

And such is the fate of our life's early promise,
 So passing the spring-tide of joy we have known;
Each wave, that we danc'd on at morning, ebbs from us,
 And leaves us, at eve, on the bleak shore alone.

Ne'er tell me of glories, serenely adorning
 The close of our day, the calm eve of our night; –
Give me back, give me back the wild freshness of Morning,
 Her clouds and her tears are worth Evening's best light.

THOMAS MOORE (1779-1852)

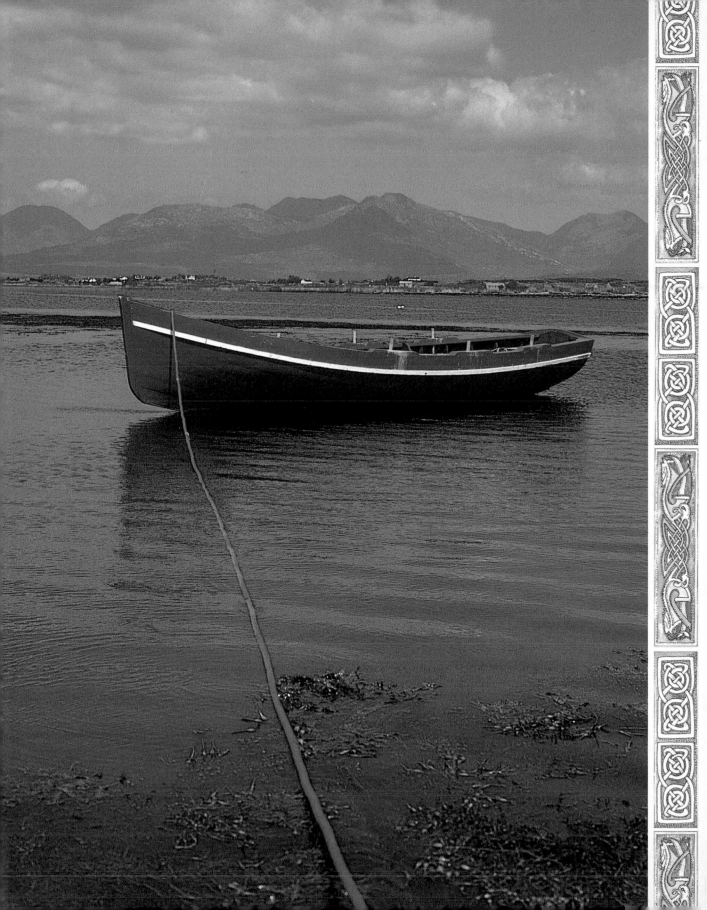

RED HANRAHAN'S SONG ABOUT IRELAND

The old brown thorn-trees break in two high over Cummen Strand,
Under a bitter black wind that blows from the left hand;
Our courage breaks like an old tree in a black wind and dies,
But we have hidden in our hearts the flame out of the eyes
Of Cathleen, the daughter of Houlihan.

The wind has bundled up the clouds high over Knocknarea,
And thrown the thunder on the stones for all that Maeve can say.
Angers that are like noisy clouds have set our hearts abeat;
But we have all bent low and low and kissed the quiet feet
Of Cathleen, the daughter of Houlihan.

The yellow pool has overflowed high up on Clooth-na-Bare,
For the wet winds are blowing out of the clinging air;
Like heavy flooded waters our bodies and our blood;
But purer than a tall candle before the Holy Rood
Is Cathleen, the daughter of Houlihan.

W.B. YEATS (1865-1939)

Right: Curraheen River, Co. Kerry

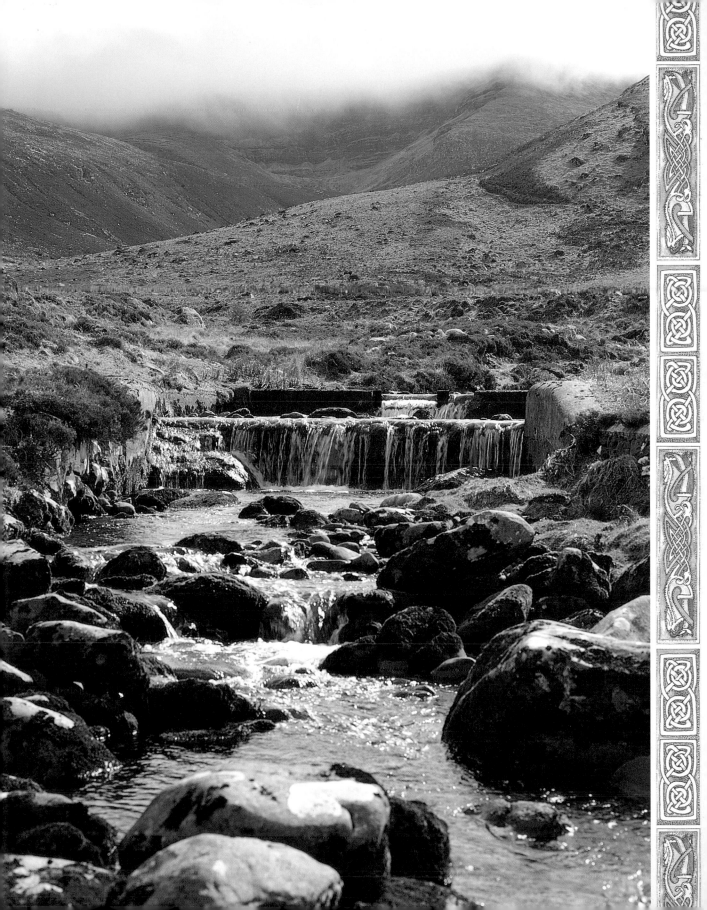

INDEX OF FIRST LINES

ACKNOWLEDGEMENTS

Acknowledgement is made by the publishers to the following for permission
to reprint the poems in this treasury:

'High Island' from *New selected Poems* by Richard Murphy (Faber and Faber); 'Bogland'
and 'The Forge' from *Door into the Dark* by Seamus Heaney (Faber and Faber); 16 lines
from 'At a Potato Digging' from *Death of a Naturalist* by Seamus Heaney (Faber and
Faber); 'The Avenue' from *Why Brownlee Left* by Paul Muldoon (Faber and Faber);
'Gathering Mushrooms' from *Quoof* by Paul Muldoon (Faber and Faber); 'The Swimmer'
and 'My Dark Fathers' reprinted by permission of Bloodaxe Books Ltd from *A Time for
Voices: Selected Poems 1960-1990* by Brendan Kennelly (Bloodaxe Books, 1990); 'The
Limerick Train' by Brendan Kennelly reprinted by permission of Bloodaxe Books; 'Achill'
by Derek Mahon , from *Antarctica* © 1985, by permission of The Gallery Press,
Loughcrew, Oldcastle, Co. Meath, Ireland; 'October', 'Canal Bank Walk' and 'Lines
Written on a Seat on the Grand Canal' by Patrick Kavanagh, reprinted by permission of
the trustees of the estate of Patrick Kavanagh, c/o Peter Fallon, Literary Agent,
Loughcrew, Oldcastle, Co. Meath, Ireland; 'In Carrowdore Churchyard' from *Poems 1962-
1978* by Derek Mahon, reprinted by permission of Oxford University Press; 'The Woods'
from *The Hunt by Night* by Derek Mahon, reprinted by permission of Oxford University
Press; 'Plougher', 'An Old Woman of the Roads' and 'She Moved Through the Fair' from
The Poet's Circuits by Padraic Colum (Dolmen Press, 1981), reprinted by permission of the
estate of Padraic Colum; 'Snow', 'Sunlight on the Garden' and 'House on a Cliff' from
Collected Poems by Louis MacNeice (Faber and Faber), by permission of David Higham
Associates Ltd; 'September 1913', 'The Lake Isle of Innisfree', 'When You are Old', 'He
Wishes for the Cloths of Heaven', 'In the Seven Woods' and 'Red Hanrahan's Song about
Ireland' by W.B.Yeats, reprinted courtesy of Macmillan London; 'The Straying Student',
'Martha Blake' and 'Her Voice Could not be Safer' from *Collected Poems* by Austin Clarke
(Dolmen Press 1974), reprinted by permission of R. Dardis Clarke and Lilliput Press;
'After the Irish of Egan O'Rahilly' by Eavan Boland, reprinted by kind
permission of the author